Divinely Beautiful

Experiencing the Power of His Beauty

Allison Finley

Divinely Beautiful

Written by Allison Finley

© 2016 Allison Finley

Cover Design: Jonathan Puckett

Photography on back cover: Hannah Marie Photography

To

My Mom and Dad

The ones who first showed me how to represent Him rightly.
Thank you for always pointing me to God and supporting me in
this journey.

*"Train up a child in the way he should go, even when he is old he will not
depart from it." (Proverbs 22:6)*

Table of Contents

Introduction

A broken and insecure sixteen-year-old girl sat with her knees drawn in against her chest. Surrounded by a dark room, she felt the musty deep red rug underneath her and the tears slowly pouring down her cheeks. She was convinced a mighty and righteous God would never accept her. Believing she had run too far, she held the thought of a loving God distant from her thoughts. *If only God truly saw my heart and destructive thoughts, He would never want me again. He would see the filth, the lies, and the sorrow and chose another capable young woman. I'm not gifted, popular, and certainly not beautiful,* she thought to herself. After believing God had already passed her by, she decided in her heart that hopelessness would always be her companion in life.

However, this story has a second narrative. While this woman was walking in defeat, her Creator was fighting for her. He saw every mistake she made, every idle word she spoke, and every defeated thought she dwelled on. Instead of leaving her wandering alone, He set a time to encounter her. While she sat in that dark room, He walked in and sat right beside her. He didn't aimlessly walk past her and choose a more likely candidate, but He stopped at her feet. Contrary to what she believed, He did not judge or condemn her. Wiping her tears and holding her side, He spoke tenderly to her. He whispered to her heart, "You are

Mine and you have always been Mine. If you allow Me, I will create beauty from your ashes." She almost couldn't believe what she was hearing. What He said sounded too good to be true. He wasn't angry with her and didn't disqualify her. He showed her the freedom of love and grace. In that moment, everything changed.

She didn't have to strive for perfection or live in regret anymore. Her shame and despair fell off onto the musty deep red rug and she stood up a different woman. This one encounter showed her she was made for something and Someone great. Instead of trying to blend in with the culture and appear beautiful, she had experienced the essence of true beauty. The beauty she tasted from the King was passionate, kind, and absolutely set her free. His beauty was not painted on by brushes, but His beauty was powerful and divine. By understanding His character, she began the journey of discovering Him and falling more in love with Him every step of the way.

As you probably already guessed, this young woman is me. My encounter with the Father forever changed my life. That dark room served as the starting point in understanding and fulfilling His dreams for me. The great news is He didn't only meet me that one time, but He continues to meet me. During my moments with Him, He has revealed His beautiful love for me as a daughter. By growing in His love and grace, I find Him to be more

beautiful every day. His beauty has captured my heart and become the passion of my life. I long to know Him and walk with Him the rest of my days.

The Lord has called me on this journey. He has called me at twenty-two years old to a walk of faith of discovering more of His beauty. He goes before me and has already orchestrated every detail. He will show my heart the splendor of His beauty and He extends the invitation to you as well. How about we do this together? Let's unravel the extravagant facets of His beauty one page at a time.

"One thing I have asked from the Lord, that
I shall seek:
That I may dwell in the house of the Lord
all the days of my life,
To behold the beauty of the Lord
And to meditate in His temple."
Psalm 27:4

Part One: The Foundations

Chapter One: Beauty - Redefined

When people hear the word "beauty" many visual images may come to mind. Some may picture pageant queens or swimsuit models. Others may envision bright blue eyes and long curly hair. For many years of my life, I associated beauty with a woman who had a slim figure and wore all the latest fashions. I eagerly watched television shows and studied the cover of magazines to learn the essence of beauty. I would straighten my hair every day and never let anyone see me without makeup, not even my family. Eventually, I bought into the lie declaring that my beauty was based on others' approval. If others my age didn't consider me beautiful, then I most definitely was not beautiful.

Can you relate to my story? I'm sure we have all felt like we didn't measure up to society's standard. Let's be real —being a woman of God in this generation is not always a walk in the park with coffee in hand. Our culture can be brutal. One moment you might hear you're beautiful at any size, and then the next ad features toned women selling sports bras. Right when we feel we have achieved the latest goal, the focus shifts and we must start the pursuit all over again. Eventually we become so tired of chasing endless trails that we hand our God-given identity into the enemy and receive a broken lie in return. Instead of basing our

worth on the Word, we listen to the whispers of darkness and believe our worth must be derived from others.

I think culture is just as confused as we are about the definition of beauty. We are constantly changing our goal and inspirations of what we want to achieve. Maybe the goal is to have the longest and lushest hair, or maybe we need to wear minimal makeup, or be able to workout without breaking a sweat? When we watch culture frantically run from one hot topic to the next, it becomes clear that humanity has no idea what they are looking for.

From a young age, children (especially girls) are taught that beauty is a goal. The goal may be far off and at times move around, but society teaches that women must always be running toward this moveable and inconsistent goal. Quickly, women learn they must appear and act a certain way to gain the title of beautiful. I remember while I was still in elementary school, I would try to resemble the pop stars of that day by acting and dressing like them. I thought if I appeared like a celebrity then surely I would be beautiful. Before I knew it, I carried this belief into my teen years and it served as a destructive stronghold which Christ gently liberated me from. However, many young women my age still believe they must gain the attention of the world to validate their beauty. If these women never learn the real definition of beauty, they will pass their

distorted belief onto their daughters. Before you know it, a generation of women will strive for acceptance from culture.

This twisted belief drives women to unnecessary measures to prove their beauty. We become harsh on ourselves and constantly criticize our bodies all for the sake of beauty. We empty our bank accounts to buy the latest makeup and spend countless hours in front of the mirror. Don't get me wrong—I'm a girly girl to the core. I love dressing up, curling my hair, and wearing a little extra makeup every now and then, and all my friends could attest to that truth. However, there's a difference between enjoying these things and allowing them to define you. Accentuating your natural beauty is fun and can even be a healthy habit. It's when women start viewing their appearance as a shield and mask that you know the enemy is at play. The enemy loves the world's misconception of beauty because it is selfish and unfruitful. When you find yourself leaning into others' opinions concerning your beauty, you can stop and realize Christ is pulling you back into the true arms of acceptance.

I'd like to stop and present a question. What if women are misdirecting their desire for beauty? What if this passion that so many women hold is actually created by God? I have never met a woman who did not want to feel beautiful. Naturally a woman will light up and form a smile on her face if a friend, or even a stranger, intentionally

looks her in the eyes and says, "You look so beautiful today." Maybe it was her first time to hear those words, or maybe she's heard them her whole life, but I can guarantee you she would gladly receive them. I can't image a woman storming off and refusing to acknowledge her friend's encouraging words. As women, we long to feel desired and represent life in this world. When others strengthen that desire within us it confirms we were designed for exactly that.

Within our DNA is wired the need to be beautiful. We want to appear beautiful, feel beautiful, and be beautiful. Our dream for beauty is so apparent when you look within your heart and the women around you. We all have two desires: to be loved and feel beautiful. Many times the enemy will come to manipulate those desires and try to steal them. No matter how much destruction the enemy has done, the two desires still remain in the core of every woman. I believe God places this natural desire within us.

Just like every person desires and needs love, every person is wired for beauty as well. The natural need for love has been manipulated by the tactics of the enemy. All around you can find marriage covenants destroyed, children raised by only one parent, and infidelity within relationships. The enemy wouldn't attack love if he didn't know it was powerful. When God is in the center of a

loving relationship, people are healed and generations are restored.

Many times you can look at what the enemy attacks and realize what is powerful in the kingdom of God. Why would the enemy waste his time on futile and empty fights? The enemy will strategically fight against the most precious things on the Lord's heart. According to a study directed by Dove called "The Real Truth About Beauty," they uncovered saddening truths for many women. They discovered "only 4% of women around the world consider themselves beautiful." Also, they found 72% of women experience pressure to appear beautiful to others.[1] It is obvious women's struggle with beauty and acceptance is under direct attack from the enemy. Since the devil is violently abusing and manipulating women's identities, it shows God has big plans for establishing beauty on earth.

If God indeed did place this desire within women, what is the importance of it? With any other desire He places in your heart, it's all supposed to lead you back to Him. The desire you have for a child brings you back to the Creator of life. Your desire for a godly marriage directs you to receive His love first. The passion to travel the world leads you to the One who gave the Great Commission. You see, every desire He placed within your heart not only leads you to the destination, but also leads you back to Him. I believe He marks every desire with His fragrance. Behind

every dream in our hearts is the sound of His heartbeat. If He didn't do this, we would quickly run to the fulfillment and realize we weren't fulfilled. We too often wonder why our striving to reach a goal still leaves us empty. The truth is it's only when you see the fulfillment with the Fulfiller you are truly fulfilled.

When you look at women who are considered beautiful in the world's eyes struggle with insecurity it all makes sense. Their need for beauty is not met by the staring eyes or the paparazzi flashes. The attention of men or their flawless skin doesn't fill their desire placed by their Creator. They will not stop striving and pushing themselves to gain more approval until they pause and hear the heartbeat of God behind their dream. When they meditate on what God really wants from them, they will realize He doesn't require what the world demands. He doesn't want you to wear the tightest jeans, have the perfect eyeliner, or have the cutest handbag. I know you're probably saying, "I know this, Allison." It's one thing to know this in your head. It's a completely different thing to know this truth in your heart. When this truth becomes reality in your life, you can say confidently, "I am beautiful" without needing to prove it.

I'll even take it one step further. God is not looking for your performance. He is not on the search for women with perfect resumes or those with well-behaved children. His love and admiration for you is not based on how you

appear to others. No, His love for you is based on one man —Jesus Christ. The blood of Jesus makes you flawless before the King. Any false notion stating you must work for God's approval can be broken when you fully realize the grace found only in the gospel. Even while the world accuses you of messy hair, being overweight or underweight, or not being pretty enough, God takes one look at you and it takes His breath away.

If God finds us absolutely beautiful, we should be able to receive those same words from others. Receiving compliments from others is not a sign of conceit or selfishness. I believe God gave us words of affirmation to build each other up. Many times God will even further affirm our unique beauty through speaking it through someone else. When a friend, family member, or spouse sincerely affirms your beauty, it should make you feel loved.

One of the toughest lessons I've had to learn is how to receive compliments. I've caught myself telling friends their compliments are not true because I woke up late that morning, I didn't wash my hair that day, or my outfit is from last season. Also, for some reason I developed the habit of making a silly face when someone told me I looked good that day. Instead of simply saying, "Thank you, so do you," I formed an odd looking smile and squinted my eyes. Ridiculous, I know. When I look back on it I just laugh at myself for the absurd habits insecurity caused me to do. It

transformed a thoughtful moment into one that was awkward and it showed I did not truly believe their words.

It really makes no sense. On one hand we want others to think we're beautiful, but on the other we run when they say we are. I've realized that's how the enemy works. He causes you to desperately run in search of beauty and then leaves you empty when you find it. In this trap, he surrounds you with fear of disappointing others and appearing the wrong way. We soon become afraid of receiving compliments, but also crave for more affirmation at the same time.

The enemy's goal is to have us solely focus on achieving physical beauty while never considering the beauty of our character. Our eyelashes may be full of volume, but our hearts are full of insecurity and brokenness. We may keep trying to solve the problem by resorting to physical measures while never consulting our hearts. If we keep striving in the flesh we realize our pursuit is not only out of reach, but also not fulfilling.

Further completing his plans, the enemy will turn women against other women and have us doubt God's design. If he continues to have his way, women will fight against each other for attention and cause men to stumble as well. Since he knows there is life or death in the tongue, he will lead women to voice their insecurities. Nothing excites his heart more than when he hears a beloved

daughter of the King say, "I'm not pretty enough because she is more beautiful than I am." The enemy will always turn your focus toward yourself and remind you of your weaknesses. You would assume with all these negative side effects no women would agree to listen to his voice. However, he disguises his voice as your own and slowly sells you more and more lies. Because God has rich divine beauty, the enemy will try to imitate it, but it will always come up short.

Earthly beauty which is what the enemy taunts you with makes you compete and compare, while His beauty completes you. Temporary beauty is never satisfied, but His beauty can rest assured. The enemy's distortion of beauty makes you feel weak and insecure, but the beauty of the kingdom empowers you. And here's the big one: worldly beauty drives you to yourself, but His beauty drives you to Him. The world will often yell, "Do more!" but the Father will whisper, "You are already enough in Me." This is why I love the Father so much. He lovingly calls my name and reminds me He makes no mistakes. He is not merely beautiful, but He IS beauty!

Of course, none of us will ever be perfect. We will fall, make mistakes, and sometimes find our worth in earthly things. There will be days you just won't feel beautiful, but even in those days, He still is. It's actually in those days we struggle with accepting ourselves that we need

His beauty the most. His beauty can realign your thoughts and remind you He never makes a mistake with His creations.

This is how Christ treats His church and His daughters, "You are absolutely beautiful, my darling, with no imperfection in you," (Song of Songs 4:7, HCSB). Have you ever heard the world tell you this? I know I haven't. The culture is never satisfied and if you're not careful, it will absorb you in the cycle of constantly preforming for more attention. The world's standard of beauty enslaves you. However, walking in His beauty sets you free. The Father's beauty allows you to unashamedly be who you were created to be. His beauty doesn't have any prerequisites or goals to meet. When you seek the Father's approval, you realize He is not focused on your appearance or impressed by your achievements. He is more concerned about your heart and seeing you walk in fulfillment.

Simply put, His beauty releases joy and transforms you more into His Son. This truth can be found in 2 Corinthians 3:18, "We all, with unveiled faces, are looking as in a mirror at the glory of the Lord and are being transformed into the same image from glory to glory; this is from the Lord who is the Spirit," (HCSB). When you study the face of the Lord and are captured by His beauty, you start to resemble it. His gracious heart, loving eyes, and passionate hope are freely available to those who sit at His

feet. This kind of beauty can never be taken away and will not disappear with old age. His beauty is the only kind of beauty you can carry in this life and into the next. By experiencing what He has to offer, the world's attempt at beauty becomes an unworthy pursuit.

I believe Solomon put it best when he heard the Lord speak these words, "Charm is deceptive, and beauty does not last; but a woman who fears the Lord will be greatly praised," (Proverbs 31:30, NLT). The answer to your longing is not found in the mirror or your jean size. Your solution to the aching within your heart is only found in the presence of the King. In His presence, He cleanses you from smeared makeup, frizzy hair, and the foul scent of sin. His beauty will transform you from the inside out as you come to know Him.

He is what every woman is searching for! A woman who honors Him will not only be greatly praised, but she will also taste and see real beauty. Your heart does not desire the approval of men; it is hungering for the acceptance found in being His daughter. You were made for so much more than what this world tries to make you believe. You were created for a beautiful and intimate relationship with the Father of all fathers!

How about we stop this senseless running in circles, chasing one fad to the next? I think it makes a lot more sense to come to the One who fills every heart and brings

peace to every soul. In this journey, I ask you to lay down your preconceived notions of beauty and lean in a little closer to your Creator. I believe you will be delightfully surprised by the measure of His love for you.

Lord,

As we start this journey, I pray that You reveal Yourself in mighty ways to each daughter. No matter what season of life she finds herself in, You declare she is beautiful and accepted in You. Thank You that You are always good and You will be faithful to each woman on this journey. Father, come and train us on what You desire from us. Heal us from wounds, bondages, and lies we hold onto. Let truth and freedom serve as a foundation in each woman's life. May we not only experience, but also behold the beauty that only comes from You.

Your Daughters,

Amen.

Questions to Ponder:

1. When you think of the word, "beauty" what words or images come to mind?

2. In what ways have you adopted the world's pursuit of beauty?

3. How has the Lord proved Himself beautiful in your own life?

4. Ask God how you reflect His beauty and how you can further do so. Write down what you hear Him say.

Chapter Two: Alive Perfume

Have you ever passed a woman at the mall and wondered what perfume she was wearing? It may be a familiar scent, but her fragrance caught your attention. The woman didn't have to create the sweet smelling perfume herself; all she had to do was wear it. You wouldn't find her in the chemistry lab each morning combining the perfect amounts of chemicals, but instead, you would see her going through her morning routine and casually spraying her bottle of perfume on herself.

She just simply applies it each morning and the scent follows her. She doesn't have to work really hard to smell attractive, all she does is agree to wear the fragrance and let the perfume do the rest. She may be at work leading a meeting, driving her children around, or cooking dinner, but if you stand next to her, you'll smell the fragrance on her. People may stop her and ask what she's wearing or others may just notice she smells different than most people. If I were in her shoes, I'd be wearing my favorite Chanel perfume. Just as women may have their favorite scent, the Father also has His favorite scent. He gives His followers a one-of-a-kind perfume called Life. In 2 Corinthians 2:14-16 it says,

But thanks be to God, who always leads us in triumph in Christ, and manifests through us the sweet aroma of the knowledge of Him in every place. For we are a fragrance of Christ to God among those who are being saved and among those who are perishing; to the one an aroma from death to death, to the other an aroma from life to life. And who is adequate for these things?

This fragrance created by the greatest Chemist never goes out of style and never clashes against your outfit. His perfume is perfect for every season and occasion in life. If you wear it, people will stop and ask why you don't smell like everyone else. As mentioned in the verse, some people may be offended, but others will receive a new measurement of hope by simply smelling the sweet fragrance. Just as a fragrance can change the atmosphere of a room, His beauty can cause freedom and victory to walk beside you. His beauty within you causes people to stop and wonder why you don't appear and act like others.

I saw this verse come to life when I was in the hallway of a hospital. After witnessing the passing of my grandfather, I stood outside the room while processing my thoughts. I wasn't trying to strike up a conversation, but a family member came to me and told me I was glowing. At first I thought it was just a kind compliment, but then he

looked me in the eyes and said, "No, really. You just glow."
In that moment, I knew he was referring to the Holy Spirit
within me. I was definitely not trying to glow, but the Holy
Spirit was shining through me and caught others' attention.

The presence of light in a Christian woman will
catch attention. In a world full of darkness, her relationship
with Jesus will shine like a lamp in a dark room. Her light
illuminates her path and makes the way clear for others.
Wouldn't it be amazing to gain attention in the right way?
This attention is not produced from wearing certain clothes
or talking the talk. No, this spotlight is only gained by
acknowledging His beautiful spirit already living within
you.

His beauty within you will make you irresistible to
others. People will pass you by and recognize the life within
you. They are attracted to His beauty because it is peace,
joy, and rest. His beauty is not desperately fighting for
attention or striving to appear better than others. The
beauty from Him is steadfast and feeds your soul. Just as a
sweet smelling perfume causes others to walk a little bit
slower and even gaze at you a little longer, His beauty
shining through you makes a memorable impression.

2 Corinthians 2:14-16 has become a verse I go back
to again and again. Each time I read it, I capture a new
insight into God's heart. As I have studied this verse, I have
noticed many interesting and noteworthy details. In 2

Corinthians 2:14, it says "But thanks be to God, who always leads us in triumph in Christ." In the original Greek, Paul painted a picture of a Roman conqueror parading through the streets with his captives trailing behind him. Within the triumphal procession, sweet incense would fill the streets, which showed victory had taken place. Those passing by in the markets would recognize the scent of victory and celebrate as they defeated their enemy.[1] This visual painted by Paul is inspiring, but how does it relate to beauty?

When you partner with His beauty, you are automatically an overcomer. When you understand and choose to live out His beautiful character, you become triumphant. You may not be a Roman general or fight a physical war, but you wage war against the spiritual realm. The lies of the enemy declaring you're not good enough become the captives behind you. The demands and pressures of the culture trail behind you as you courageously walk toward the Creator of beauty. While you take your march, a sweet fragrance fills the streets, homes, and market places. This fragrance smells a lot like freedom, and it soon becomes contagious. People will pause in their daily routines and watch you live in victory. It's not a prideful walk, but one you can invite others to join. Your victory lap is full of love and joy because the fragrance of life surrounds you.

Sisters, that's what walking in His beauty is like. Living in victory does not require you to fight for attention or affirmation. You don't have to stop and compare your beauty to other women on the streets either. Instead, you stop and let the sweet fragrance of Jesus empower them to join the triumphal procession. Beauty does not have to be vain and self-focused, but it can be inspiring and set women free. The incredible thing is this beauty that I talk about is not from you, but it's all from Him.

He is the One who gives the victory. He is also the One who entrusts you with His life. God could have easily kept His Spirit to Himself, but He graciously decided to share His beauty with us. His beauty is the only solution to the aching within our hearts. The beauty flowing from God delivers you from the battle ground and allows you to align your heart with His. I pray we never take that honor for granted. May we understand His gracious gift and seek to display Him in all areas of life.

Although the beauty of the Lord is freely available, many people have yet to claim it as their own. Instead of allowing His character to shine through them, many women bury His gift under the weight of the world. Their days are not marked by victorious battles or the incense of His fragrance. Nor do they walk triumphantly through their days. They find themselves still on the battle field, instead of enjoying the parade in the streets.

Remaining on the battle grounds produces stress as they believe they must fight for victory. They assume if they become stronger and develop the right tactics, they will finally overcome. After failing again and again, they feel shame as they are stuck in the mud of the battle lines. They allow the enemy to run over them, continually causing them to believe their defeat is permanent. Not only is their defeat never ending, but they also believe they are the only ones left fighting. Looking around, they think no one is on their team. With all these odds stacked up against them, they eventually accept that victory will never be theirs.

If only they could raise their heads and see the enemy has already been slain. Their victory has already been won by the shedding of blood from the Commander. They are not stuck in their mess, but they can freely join the victorious parade of the Conqueror. Yes, an enemy will wage war, but this daughter's victory is already guaranteed. Daring to set their gaze straight ahead, they would see this inscription along the walls,

> Because God's children are human beings—made of flesh and blood—the Son also became flesh and blood. For only as a human being could he die, and only by dying could he break the power of the devil, who had the power of death. Only in this way could

he set free all who have lived their lives as slaves to the fear of dying. (Hebrews 2:14-15, NLT)

As they understand the battle has already been won, rejoicing would erupt from their hearts as they jump up and down and rest from their weary fighting. These tired warriors no longer have to wake up with despair and fear the unknown. The realization that the power of the devil has been destroyed changes their whole perspectives and plans for the day. Now they can wake up with joy knowing that victory has already been purchased and it freely belongs to them. The good news bubbling within them would overflow into their family and friend's lives as they celebrate their victory. Eventually their new measure of life would go beyond loved ones and begin to affect strangers they come in contact with. Bringing the good news of victory into the streets, the incense of freedom would trail behind them. No longer are they marked by hopelessness, but they have experienced rebirth. The fear of defeat no longer controls their thoughts. They are able to move forward and anticipate their future full of life.

As a daughter of the King, victory is your birthright! The Father never designed you to fight for a position or attention from others. You are not called to remain on the muddy battlegrounds. You are created to rejoice in the celebration of His victorious blood! *You were never designed to*

fight for beauty. You were designed to receive Beauty. He graciously offers His beauty and desires to see you walk in it. The beauty He extends will produce life within you and cause you to shine for everyone to see.

Would you like to experience this freedom and victory in your own life? Does the thought of empowering and encouraging other women excite you? If you're reading this book, I bet it does. Having this foundation of a live beauty is crucial before we can ever move forward.

In the next few chapters, we will discover what makes Him so beautiful. We will study the heart of the Father, Son, and Holy Spirit, along with the importance of the Word. You may have to face wrong beliefs you hold onto. You may even have to open your heart to Him in ways you have never done before. I know this journey may feel uncomfortable and scary at times, but sweet daughter of the Most High, it is so worth it. Absolutely nothing in this world can compare to the beauty of the King. The more of His beauty you unravel, the more you step into the calling He has for you! Let's join hands and go into this unforgettable journey together.

Questions to Ponder:

1. How would you define the world's beauty?
2. Would you consider yourself beautiful? Why or why not?

3. How do you feel God sees your beauty?

4. What are some practical ways you can focus on His beauty instead? (For example, write down a Scripture and read it every day, look in the mirror and ask what God thinks, think about times in the past when He delivered you, etc.)

Chapter Three: Seek the Encounter

If I described my favorite dessert, I would tell you exactly how I like my frozen yogurt. With the sweet flavor of cake batter topped with dark chocolate and granola and drizzled with caramel sauce, you could imagine what it would taste like. You could probably picture it in your thoughts and maybe even start to crave it. My words might peak your interest in frozen yogurt, but it's not until you taste it yourself that you really know what I'm talking about. You would need to grab a bowl, create your favorite concoction, and sit down to experience it for yourself.

I could tell you in every sentence of this book how beautiful my God is, but if you don't experience Him for yourself it would just be a waste of time. Of course, you would gain some knowledge about Him and maybe learn some new Bible verses. At the end of the day, it's not your knowledge that will transform your life, but your encounter with Him.

Growing up I memorized plenty of Scripture and learned a lot about God. I always held a desire to know Him more and serve Him. However, even with my vast knowledge of God, I still felt empty on the inside. I still ran to worldly offers to provide my worth in my early teens. My knowledge of Him provided an understanding of His

character, but it didn't provide the relationship I desperately needed.

It wasn't until I stopped, poured out my heart, and listened to what He said that I truly gained an experience. It took one encounter with God for my life to flip right side up. After feeling His tangible presence and hearing His voice, I viewed life differently. By continually growing in my relationship with Him, I realized He was beautiful. Yes, He was a lot of characteristics I learned about from a young age, but He was also so much more. The depths of His grace and kindness could never be expressed with mere words. His love and acceptance cannot be detailed on paper. All of these divine characteristics must be experienced for it to produce power in your life.

There was a man in the Bible named Moses who refused to be satisfied with knowing facts about God. He was so hungry for an encounter with God that he said, "I pray You, show me Your glory" (Exodus 33:18). God didn't disqualify Moses because he killed a man or struggled with public speaking. He didn't skip over him because he had a strange upbringing. He knew every detail of Moses' life would work toward the ultimate goal. The fact that Moses wanted to know Him more excited the heart of God. God knew this one encounter would pave the way for the Messiah.

Experiencing the presence and glory of God completely changed Moses' future. When Moses finally yielded to the call of God despite his weaknesses, God blessed him with an encounter that would forever change his life.

What I love about this story is that God didn't just show His presence to Moses and allow him to merely witness it. God didn't present His presence as a movie and allow Moses to sit and walk away unchanged. Because Moses dared to draw near to Him, even when everyone else was afraid, Moses gained an encounter. God decided to place His presence inside Moses. Moses began to reflect the presence of God because the Father placed it as a deposit in his heart.

It says in Exodus 34:29, 33-34,

It came about when Moses was coming down from Mount Sinai (and the two tablets of the testimony were in Moses' hands as he was coming down from the mountain), that Moses did not know that the skin of his face shone from speaking with Him ... When Moses had finished speaking with them, he put a veil over his face. But whenever Moses went in before the Lord to speak with Him, he would take off the veil until he came out.

His face literally shined from the presence of God. This kind of encounter is not only for the old covenant, but it is even more glorious in the new covenant. Since the new covenant has the precious blood of Jesus as atonement for sins, the cross provides a new measure of life. 2 Corinthians 3:7-11 speaks of the glory found in the new covenant,

> But if the ministry of death, in letters engraved on stones, came with glory, so that the sons of Israel could not look intently at the face of Moses because of the glory of his face, fading as it was, how will the ministry of the Spirit fail to be even more with glory? For if the ministry of condemnation has glory, much more does the ministry of righteousness abound in glory. For indeed what had glory, in this case has no glory because of the glory that surpasses it. For if that which fades away was with glory, much more that which remains is in glory.

When you get in the presence of God you are surrounded by life-giving glory. You don't have to remain seated and leave His presence unchanged, but you can shine too! He can place His radiant beauty inside of you if you dare to be with Him. Some may be afraid to approach Him or others may consider you insane for spending time with Him, but I can guarantee you everyone will see the

difference. Every time you encounter His presence, His beauty shines brighter and brighter within your heart. If someone is shining, it's hard to miss them.

Through the coming chapters, I will tell you a lot. I will share my experiences and how He has changed my life. All of these moments with Him are not reserved with my name on it. These encounters are not tied up in a pretty box addressed to "holy people" or "those who have never made a mistake." Daughter, He does not look at your failures and disqualify you. If He did that, I would still be stuck in my mess. If you have accepted the blood of Jesus to cover your sins, then you are declared righteous in His sight (Romans 3:21-26). I know this can sometimes be hard to believe, but He is not a liar (Numbers 23:19). He does not accept you in one moment, and then condemn you in the next. He is forever constant and you are forever welcome in His presence.

The ultimate example of this is found in the life story of Paul, formally known as Saul. Paul knew a lot of scripture and strived to live a holy life. He later said in Philippians 3:4-6 (HCSB),

> If anyone else thinks he has grounds for confidence in the flesh, I have more: circumcised the eighth day; of the nation of Israel, of the tribe of Benjamin, a Hebrew born of Hebrews; regarding the law, a

Pharisee; regarding zeal, persecuting the church; regarding the righteousness that is in the law, blameless.

Though it seemed like Paul had it all together, he still lacked an important quality. He lacked an experience with God, until one day when he traveled down a road to Damascus. On the road, Paul was focused on killing the disciples of the Lord. He assumed if Christ's closest friends were murdered, then surely he would gain more power and holiness. Paul was definitely not planning to encounter God, but that is exactly what happened. The Lord didn't disqualify Paul or decide he was too cruel. God didn't pick a more likely candidate, but chose Paul, even when he was still in his mess. The Father graciously revealed the power of His presence to him. The account in Acts says, "As he traveled and was nearing Damascus, a light from heaven suddenly flashed around him. Falling to the ground, he heard a voice saying to him, 'Saul, Saul, why are you persecuting Me?'" (Acts 9:3-4, HCSB). Paul thought he found his purpose in life by killing the Christ-followers. However, one encounter with God changed his trajectory. He soon discovered the calling on his life and became one of (if not *the*) greatest influences on the early church. This one encounter birthed a revival within him, and millions to follow.

It is never too late for you. If God would purify and use the life of a murderer to establish His kingdom, then He can most definitely use you. I can guarantee you the Father was excited to encounter Paul; He knew it would change the rest of history. What if your one encounter could carry the same power? What if by simply being available and allowing Him room in your heart, He came in and changed your life forever? It can happen because I'm living proof of it!

The Father really likes to meet with people the world would normally skip over. Jesus met with the prostitutes, tax collectors, and those with diseases. If you could walk with Jesus, you wouldn't see Him only in the company of spiritual people. Lovingly, He would stop for the children, those with broken hearts, and the women who didn't believe they were worthy. If these people were willing to spend time with Him, He would address their needs and fill them with acceptance. He would show them they too could belong in the kingdom. These people, though the world considers them weak, have a heavenly Father who desperately desires to meet with them and show them who they really are. If they accept the gift of grace, they could be declared children of God as well! That's good news!

Do you realize if you are a child of God, then you are a daughter of the Most High? I don't know what kind of earthly father you have, but our heavenly Father deeply

loves you. I absolutely adore my dad. Anytime I need him or just want to talk, I know he is only a phone call away. He doesn't get upset when I have a question or tell me I'm wasting his time. I love the moments when I come home and my dad comes to the door and gives me a big hug. My dad is excited to be around me and he loves to hear what's going on in my life. Although my dad is incredible, my heavenly Father is even better. The heavenly Father understands the depths of your heart and sees your shame and fear. He sees your dreams and desires and longs to see them fulfilled.

If you are truly a daughter of the King, then you have free access to His throne room! Just as I can go sit on the couch with my dad, you can go into your Father's room and spend time with Him. You don't need to wait to see if He's too busy because you are always accepted. No matter what time of day it is, or who's around, you can always approach your Father. When you step near Him, He gets excited. He loves to hear your voice and just simply spend time with you. There have actually been moments when I'm in His presence and I wonder what the Lord wants me to do. I'll think maybe He wants me to start praying or open my Bible, but many times He will lovingly whisper, "Just sit here with Me." Everywhere you are, whether it's in bed reading a book or running to your next task, He is waiting to encounter you. He wants to do life with you, not only on

Sundays, but every day of the week for the rest of your years.

A lot of people have wrong misconceptions about God encounters. You don't need to sit in a dark room, light a candle, and try really hard to hear His voice. You could be pushing a cart through the grocery store and have a conversation with Him at the same time. That's why Jesus sent the Holy Spirit. Jesus was a man who could only be at one place at a time, but the Holy Spirit is always with you. The Holy Spirit is a direct representation of Jesus and always has truth to share to your heart. If you tune in to what He is saying, you can walk in freedom and revelation every day of your life.

The Holy Spirit is a beautiful friend. He's not like friends from the past who have left you, said something rude, or solely looked out for their own interest. There's a reason "Holy" is His first name. His character is the embodiment of the fruit of the Spirit. He is always loving, joyful, peaceful, patient, kind, good, gentle, and self-controlled. When you need encouragement, He is only a whisper away. Many Christians are acquainted with the idea of having a relationship with the Father and Jesus, but what about the Holy Spirit? I believe the Holy Spirit wants to develop a deep and rich relationship with you! I believe He wants to speak to your heart and create a trust within you.

To build a relationship with the Father, Son, and Holy Spirit, all you need to do is give Him your time and heart. Give Him just a few minutes of your day and He will encounter you. He may come with a strong prophetic word, or He may just come and sit with you. He may discipline you and show you the right way, or He may wipe away your tears of grief. God always knows what you need, even when you don't have the slightest clue.

However, there are many times we know exactly what we need from His presence. In those moments you can come boldly before the throne of grace and ask for His provision (Hebrews 4:16). He loves to care for His daughters, but He cherishes His relationship with you above all. I encourage you to guard your heart against bringing a checklist before Him. I've seen the enemy play with my emotions and cause me to approach the Father with an agenda mindset. I'll want to know answers to a list of questions I have for Him. I would never dare to say it out loud, but my attitude is saying, "I don't have much time. So, Lord, this is what I need You to do for me."

That might sound crazy, but how many times do we as women do that exact thing? We want answers and solutions fast. In our hearts, we are saying, "If anyone should understand our busy schedule, it should be God." We are partly right. He does know our schedules, but He also knows that many times the solutions we want are not

what we really need. We might want an answer to prayer, but He might want to give you peace instead. Or even, we might expect God to show up in miraculous ways, but He might desire to teach us patience in the storms of life. When we bring preconceived ideas into His presence we are actually missing out on experiencing the full measure of His glory.

It's all about coming into His presence with open arms. Yes, present your needs, worries, and questions to Him, but also understand His presence is always enough, even when things don't make sense. By His grace you can leave your to-do list at the door of His throne room, and enjoy just being with Him. When you're with your closest friends, you might have moments when no one says anything, but you're still perfectly content. I believe that's one of the signs of a mature and stable relationship. You can have that same kind of relationship with the Father. You can be so content in Him that no words need to be spoken because you feel natural with Him. Your heart can be fully rested because you know He is with you and He approves of you.

With any mature relationship, it takes time to build. It involves commitment and consistency. It may feel strange to interact with a God you can't physically see. Don't listen to the lies of the enemy saying, "You're not cut out for this" or "You're doing it wrong." How can you spend time with

God wrong? Sister, I can guarantee you were made for a heavenly relationship. You are designed to reflect His beauty! Keep spending time with Him, and you will keep growing as you understand more of who He is.

As we progress through this book, allow each section to create a deeper encounter with Him. Spend time after each chapter to ask Him questions you may have. He's not afraid of your questions or doubts. Also, I find journaling to be very effective when listening to His voice. Maybe He'll give you a song to sing or a Bible verse to memorize. Be obedient in His presence and He will bless you in enormous ways!

When I first encountered His presence, I thought it was a once in a lifetime experience. I was absolutely blown away by how cool God was. I remember telling my youth pastor, "Nothing could top what happened tonight!" But guess what? The very next night, God encountered me again and filled me with His Spirit. If I had remained satisfied with yesterday's encounter I would have missed out. I would have assumed that one night was a rare occasion. Thankfully, through my hunger for Him, I learned experiences with Him do not have to be rare. In fact, they can even be normal! You can never reach a limit in His presence. You can always have more of Him. That's why we call this Christian life a journey. You'll have some twists in

the road, but there's always another step to take with Him until we reach eternity.

So, let each chapter serve as an opportunity to meet with Him. I believe the Lord will highlight issues or questions in your heart and He is waiting to lovingly address them. Just as He has plans for me while writing this book, He has plans for you while you read it. Maybe you will experience Him for the first time, or maybe He will set you free from bondage. I don't know what He wants to do uniquely in your life, but I do know He wants to speak to you. He is waiting with open arms ready to show you the vastness of His beauty. He is willing; all you have to do is say yes!

I need to ask you one last question. Will you give Him the chance to show His beauty to you? He wants to see you walk in the empowerment of His beauty—all you need to do is spend time with Him, study His character, and rely on His Spirit. The more time you spend with Him, the more you will fall in love with Him. When you are captured by His love, radiating His beauty will come so naturally to you. The Lord is already waiting to meet with you. He is so excited to see you on this journey. So, what do you say? Are you ready to encounter more of His presence? If so, let's do this together!

Questions to Ponder:

1. Have you ever encountered His presence? If so, what was it like and how did you feel? If not, what do you believe holds you back?

2. How can you create time in your schedule to spend time with God?

3. If you could spend time with Him right now (which you can!) what questions or concerns do you have on your heart?

Part Two: The Father, Son, and Holy Spirit

The Father

The Red Light's Revelation

Standing in the most broken place I could ever imagine, the Father showed up. Red-lit windows with beautiful women selling their bodies behind them surrounded me on all sides. I dedicated three months of my life to share my heart with prostitutes in Amsterdam, Netherlands. Some days were full of life and victory, while others felt like every emotion was resting on my shoulders. Despite the condition of my heart, everything paused as the Father tenderly spoke to me in the middle of the red light district.

I could see hurting women illuminated by red lights. I could also spot tourists, along with numerous men, gawking at the women as if they were window-shopping. Many would simply look at the ladies and keep walking, while others would spot a lady and ask how much she charged. If the amount seemed reasonable enough for their wallet, they would step inside and partake in the brokenness. In the midst of the spiritual darkness, the Father showed me a piece of His heart.

He didn't speak endless amounts of words. Instead, He opened up His heart and allowed me in. His heart was broken for not only the people in the district, but also for what the enemy has stolen. Before Adam and Eve ever stepped on this earth, the Father created sex and declared it

was good. The beautiful gift He planned on giving to humankind not only produced children, but also was designed to unite man and woman within marriage. Within a marriage covenant, sex was created to reveal the connection between Jesus and the Church.

Since sex was designed to be a powerful blessing, the enemy desired to strip the gift of its power and attempt to mask it as simply a physical act. Also, instead of strengthening people, sex has brought despair, disappointment, and shame to those who abuse the gift. Nothing reflects that reality more than the red light district of Amsterdam. Despite the deception within the city, the Father provided a new measure of hope. He painted a picture of the red light district lined with flowers in my spirit. These flowers were colorful and bloomed each day with fresh life.

According to this picture, onlookers could walk through the canals of Amsterdam and leave refreshed and full of joy. If you merely look at the red light district from a physical view, this vision would seem completely contrary to reality. However, the Father sees the physical, but also the spiritual. He sees women coming to the knowledge of Him and flowers blooming on every corner as windows continue to lose business and close down.

The numerous prostitutes and intense spirit of lust did not intimidate the Father. He wasn't willing to back

down, but He dreamed of bringing new life to one of the darkest places on this earth. Every woman and transsexual working behind the windows is deeply loved by the Father. Even the men paying for the sexual services are known and adored by the Father. With this revelation, I was able to connect with the Father in a new way.

One of the greatest lessons I learned while ministering in Amsterdam is that the Father is not a quitter. He does not look at your situation and view you as a hopeless cause. Neither does He allow your sin and rebellion to prevent you from turning back to Him. No matter how far you attempt to run, the Father eagerly waits for you. If the Father has not forsaken the red light district, He has not forsaken you. Instead of judging you by your actions, He sees you as the daughter He designed you to be.

A true revelation of the Father will change your situation and future. As I met with women behind the windows, I witnessed daughters realizing who their Father really is and the intensity of His love for them. The answer to hurt and pain within women's hearts is not hiding, but boldly coming to the Father. He sees your wounds and He desires not only to heal them, but also to show you who you are in His kingdom.

With this start, I believe the Father wants to show you a deeper measure of His beauty. Just as His heart is toward the prostitutes in Amsterdam, His heart is focused

on you, no matter where you find yourself today. Daughter, you have caught the attention of your heavenly Father and He longs to show you new facets of His character. He is a beautiful King, and He desires to share His beauty with each daughter.

Chapter Four: The Father's Heart Exposed

While I was writing this chapter, I kept encountering the Father everywhere I turned. All the Scripture I read, all the songs I listened to, the topics my professors discussed in class, and the sermons I heard all revolved around the importance of the Father. I concluded there was no way this was all coincidence. So, I flat out asked Him, "Father, what are you trying to tell me?" He said, "I just want to be with My children. I want to do life with each one of you."

He then gave me a picture of a father teaching his child how to ride a bike, walking his daughter down the aisle, and an older man playing with his grandchildren. The heavenly Father wants to be active in every detail and stage of your life. He not only wants to be present during the most important days, but also in the days that seem the most mundane. If He really is a good Father, which He is, then He loves to spend time with you and teach you more about Him.

I heard a quote from a sermon at Bethel Church in Redding, California that I believe perfectly describes how amazing the Father is toward His children. Paul Manwaring, in a sermon titled, "Releasing Fathers: Revealing the Father," said, "If they knew how good the Father really is, everybody would want Him to be their

Father."[1] The Father's heart is passionate for every child of God. His love and desires for you can never be compared with any earthly man.

Many Christians know facts about the heavenly Father, but few experience them. Sure, they might know He is good, but few walk through the fiery furnace testing His goodness. In the moments in my life when I was surrounded with fear, doubts, and frustrations, His faithfulness was most apparent. Also, in the moments when I felt unlovable, His beauty and grace shone brighter. When my heart felt as if it was beyond recovery, He showed me His healing power. The moments that produced the most fear also produced the greatest intimacy with the Father. Life without the Father is lacking in fulfillment and true joy. As children, we were designed to cultivate living relationships with our Father and walk with Him in each season of life.

In these moments, you can either turn to your emotions or turn to the One who created them. Every time I chose the second option, He not only held me while wiping my tears, but He also taught me His heart. He is passionate about His daughters, and He is concerned with every facet of your life. Nothing goes unnoticed from His eyes. With each season, He remains faithful to your heart and dependable for each passing day. We will all walk through challenging and seemingly-unfair situations. Your

emotions may immediately want to avoid the Father out of shame and fear. You may even feel God is not concerned and that He will not act. However, in the hardest moments of life, you can actually experience the heart of the Father the strongest. If you trust Him, despite outward circumstances, His beauty will radiate and provide light to your despair.

Although it may seem forced, calling out to the Father is the most natural act you can do. Wired into your DNA is a need only the Father can fill. In fact, it even says in Galatians 4: 6-7, "Because you are sons, God has sent forth the Spirit of His Son into our hearts, crying, 'Abba! Father!' Therefore you are no longer a slave, but a son; and if a son, then an heir through God."

No matter how your earthly father treated you, you are not a slave. There is no need to run from Him out of fear of rejection or disapproval. His love and acceptance for you is as constant as the waves of the sea. You not only get the honor of serving the King, but you also get to share His name. In fact, the term "Abba" was the very word Jesus used to speak to the Father. A deep relationship with the Father is no longer solely reserved for Jesus, but we are adopted into the family. Did you know that the Father views you as He viewed Jesus? Before His betrayal and crucifixion, Jesus prayed for you and for all future believers. He prayed in John 17: 23, "I in them and You in Me, that

they may be perfected in unity, so that the world may know that You sent Me, and loved them, even as You have loved Me."

As children of God, we are called to be united with the Father. He is not distant or waiting for you to say the magic words, but He is fully available to you! The bond that ties you to the Father is His love. He has laid out everything you need—all you need to do is reach out your hand and feel His heartbeat for you. He has offered the sacrifice needed for you to come before Him. He has called you by name and extended His goodness to you. The invitation He offers is full of faithful love that will follow you the rest of your days. The Father stands before you with every answer to your questions and problems. He is ready to be your Peace, Comforter, and ultimately, the best Father you could ever have. He really is this good, and He is more beautiful than I could ever describe.

When you spend time with Him and learn His character firsthand, His beauty becomes evident. He's not like many fathers who get upset and treat you harshly. He's not distant or neglectful. His heart is wild for you, and I find His pursuit of us to be absolutely beautiful. Compared to earthly beauty that forces you to meet expectations, the Father portrays a beauty that freely accepts you for you. You can feel at home in His presence. In fact, you can even take

off your shoes, cozy up with a soft blanket, and have a conversation with Him.

Contrary to what you may believe, the Father is not limited to the church alter. In fact, some of the most intimate times I have had with Him have been when I least expected it. I could easily be driving down the road, standing at work, or getting ready in the morning, and the Father will speak. As I said in the beginning, He wants to be involved in every single detail of your life. Yes, that means He wants to sit with you in the car. The Father wants to work with you and even fold laundry with you. Since He is so close, He is only a whisper away.

If you need encouragement or strength in your day, the solution is found in the presence of the Father. The sweet words pouring from His lips are full of truth and freedom. His words will also carry the reminder that you are His daughter, and you have been joyfully adopted as His own. Listening to what He has to say will clothe you with His perspective. When you are dressed in His thoughts, you are also covering yourself in the beauty of the Father.

As we discussed in the first chapter, true beauty sets you free. Beauty found in appearance is constantly striving and performing, but inner beauty is accompanied with peace. True beauty liberates you and empowers you to love others relentlessly. In the presence of the Father is the essence of true beauty. When you step into His presence,

His beauty heals, restores, and encourages you to love Him more. You will find grace, acceptance, joy, and direction as you rest in the presence of the beauty Maker.

What makes the Father's beauty different than other beauty? I'm glad you asked! Let me just tell you why His beauty is one of a kind. Before your first breath and cry ever came from your lips, He was already in love with you. Your name and face were already imprinted on His heart before you were even conceived. He was watching over you and singing over you when you were just a baby. Even when you played with your friends at a young age, He was smiling and rejoicing with you. Every day you felt on top of the world, He was celebrating with you.

He was not only there in your best days, but also in the days you felt your heart breaking in millions of pieces. Every night you cried yourself to sleep from a broken heart, He was there. He gently held your tears and desperately wanted to give you His hope and life. Every time you tried to run away and find your worth in earthly prizes, He was chasing after you. The Father goes before you during every moment of every day. He sees you and knows the burdens on your heart. When you wake up in the morning, He is already thinking about you. Before you even step out of bed, you already have His complete and undivided attention. Even when you are sleeping, He is pleased and delighted in you. He can't wait to spend time with you and speak to your

heart. While you go through your daily schedule, He is dancing over you.

Nothing excites His heart more than showing you His love. The Father finds you so lovely and He is absolutely captured by your beauty. Yes, He is captivated by you. His heart spills over with joy when you focus your attention on Him. When you give Him your heart and thoughts throughout the day, He cherishes those times and loves to be with you because you're His daughter. While you wrap up your day and crawl back in bed, He is still thinking about you.

As a daughter, you completely capture the Father's heart. When He looks down on you, He can't help but smile. I am excited for you as you grow in your knowledge and love for your Father. No matter where you find yourself, there is always deeper intimacy yet to be experienced. I know He is calling us all into more fulfilling relationships with Him. To reach this place, we must also address hindrances that keep us from experiencing more of Him. We must face wrong beliefs and find the root causes of the fear that keeps us distant.

It could be easy to skip over the next chapter. Facing past hurts and disappointments can often feel uncomfortable. Despite how strange you feel, this honesty is required for true breakthrough. You are not alone in this journey, but the Father is right beside you and holding your

hand, and full of anticipation as you come to know Him greater.

Questions to Ponder:

1. Before this chapter, what was your view on the Father? Has your view on the Father changed and if so, how?

2. The Father longs to walk through each day with you. How can you intentionally be more aware of His presence?

3. Ask the Father how you can draw closer to Him and receive His love. Spend some time listening to what He says and write down what you hear.

Chapter Five: The Liberating Truth

If the Father truly is this beautiful and loving, why would anyone run in the opposite direction? You can't find this kind of love in the world. One of the biggest hindrances to experiencing the Father's heart is believing a misconception about Him. We live in a broken world that produces broken earthly fathers. For many people who grew up with distant, abusive, or uncaring fathers, it can be easy to believe the ultimate Father must be like that too.

After time in prayer, I started remembering hurting women I have met. Some women came from healthy families, while others experienced abuse from their own family. Despite their upbringings, each woman had an aching in her heart for a Father's touch. Instead of running into His embrace, the enemy had sold her lies about His character. These lies she believed caused her to keep the heavenly Father out of conversation, and definitely out of touch. Remembering their stories led me to the realization of the most common lies women accept. Here are three of the biggest lies many women believe about the Father:

1. *The Father is angry with me; therefore, I am afraid of Him.* It can be tempting to consider all your mistakes and assume the Father's righteousness bans you from His presence. You can stack up all your idle thoughts, sinful motives, and wrong choices and immediately believe those sins

serve as a dividing wall. However, it is actually the opposite. His righteousness through the blood of Jesus is what accepts you to be with Him. The enemy uses fear to cause you to run away from your Father. Fear is a complete lie of the enemy. Satan is actually the one who is afraid. The devil knows if you find your identity in the Father, you are unstoppable in the kingdom. Did you know fear is always contrary to love? It even says in 1 John 4:18 that perfect love (in other words, His love) drives out all fear. When you accept His unconditional love for you, you can step into your role as a daughter of the King.

The goodness of being a child of God is understood in 1 John 3: 1-3,

> See how great a love the Father has bestowed on us, that we would be called children of God; and such we are. For this reason the world does not know us, because it did not know Him. Beloved, now we are children of God, and it has not appeared as yet what we will be. We know that when He appears, we will be like Him, because we will see Him just as He is. And everyone who has this hope fixed on Him purifies himself, just as He is pure.

This love I describe is real and alive. The Father's heart for you is completely pure and void of all hidden motives. He is not seeking to manipulate and trick you into service. Above all He desires for you, He longs for your heart most of all. Every time you decide to surrender more of your heart to Him, the more you will be like Him.

There is no need to fear a Father who desperately wants to hold you and fill you with love. His presence is the safest place you can find refuge in trouble. The lie stating that He is angry falls to the waste side at the reality of Micah 7: 18-19,

> Who is a God like You, who pardons iniquity and passes over the rebellious act of the remnant of His possession? He does not retain His anger forever, because He delights in unchanging love. He will again have compassion on us; He will tread our iniquities under foot. Yes, You will cast all their sins into the depths of the sea.

The cross proves the Father desires love, not anger. He is not dwelling on your sins and waiting for retribution. The price for sin was already paid for by the Messiah. In fact, the Father's righteousness is satisfied by our Advocate, Jesus Christ (1 John 2: 1-2). Since Jesus pleads our case, we can be set free from fear of God's wrath.

Your heavenly Father is approachable and welcomes you in His presence! If you struggle with fear in approaching the Father, read that last verse many times. Dedicate time each day to mediating on this truth. Let His mercy and grace overwhelm you as fear is ruined.

2. *The Father made a mistake with me; therefore, I avoid trusting Him.* Contrary to what the enemy may try to convince you, the Father does not make mistakes. All of His ways and plans for you are perfect. He has every moment of your life already planned and designed. In His heart, your days are designed to be filled with joy and intimacy with Him. He longs for you to walk through every day assured with His acceptance and delight. During those times your emotions are screaming that your desires and dreams will never come to completion, silence them. The Father knows every desire on your heart and He has a perfect time to fulfill those plans. If He created all of creation, He can speak your desires into existence in the perfect season.

Your heart fills His desires and dreams. He finds you beautiful and completely worthy, daughter. He calls you beloved and chosen. You hold a unique and special place in His heart that only you can fill. You will never find Him comparing your gifts and talents to anyone else. Since He created your heart and passions, He already finds them flawless. Let this beautiful truth sweep over you,

For You formed my inward parts; You wove me in my mother's womb. I will give thanks to You, for I am fearfully and wonderfully made; wonderful are Your works, and my soul knows it very well. My frame was not hidden from You, when I was made in secret, and skillfully wrought in the depths of the earth; Your eyes have seen my unformed substance; and in Your book were all written the days that were ordained for me, when as yet there was not one of them. (Psalm 139: 13-16)

If He handcrafted you in the womb, He definitely cares about every part of your life. He sees all your days laid out, and He calls them beautiful. The Father has never failed, and He didn't start with you. Despite what others have told you, you have been created with a powerful purpose! The fact that you are living, breathing, and reading this book is a sign of His purpose for your life. He does not create empty or useless things. Every part of His creation is designed to bring Him glory, and that includes you and me.

I dare you to let go of this lie and embrace the truth. The truth states you can trust in the faithful Father. You can place your desires at His feet and embrace His perfect plans for the rest of your days. He sees you and knows the depths of your heart. Those little desires and those big

dreams have not escaped His eyes. Since you are His daughter, He longs to provide your every need and remind you that you are His. Your Father has not overlooked you, but you have caught His attention. Even in the situations that don't go as expected, the Father still has a plan. When you feel surrounded by failures and disappointments, the Father still has His loving gaze on you. He is not out to punish you, but He is in the business of blessing, especially those who belong to the family. Because He is forever good, He can be trusted in holding and shaping our lives.

If you believe the truth declaring you are intricately designed in His sight, you will experience Him in deeper ways. Your heart will be opened as He affirms His delight in you. This truth will also connect you with His favor and blessings. The dreams you hold within your heart will be fulfilled in the presence of your loving Father.

How about we throw off the burden of self-reliance? We were never designed to carry everything ourselves; the Father is a gentlemen and He comes along side us and offers to carry our load while asking us to trust Him. Once your load is removed, you can cover yourself in His approval and love for you as His daughter.

3. *The Father does not approve of me; therefore, I will walk in shame.*
Here's the truth: The Father is not disappointed in you and He freely accepts you. Let me say that again. Daughter, He is not disappointed in you. He does not measure your

success by the world's standard; He instead focuses on your heart and obedience. Jesus shed his blood for you because the Father knew you would make mistakes and fall. With knowledge of your past, present, and future sins, He still decided your heart was worth the death of His Son. Do you really understand that? He is absolutely crazy about you! No matter how many mistakes you think you have made, you are accepted in His arms. He longs to hold you and affirm your identity in Him.

While ministering throughout the red light district, I met many prostitutes who believed this lie. Yes, God is calling them out of a lifestyle of sexual sin; however, God is not ashamed of them. As I spent time with the ladies behind their windows, I offered to pray for them many times. Instead of eagerly desiring prayer, many would explain they didn't want to talk with God while at work. They would much rather pray to Him when they were at home or not behind the windows.

I respected their wishes, but I would always remind them God is willing to meet with us wherever we are. Even in the middle of their mess, the Father would lovingly come fill their window and remind them of their true identity. He is not ashamed or embarrassed to call them His children. He sees each one in their brokenness and is reminded of Christ's atonement. Many of these ladies allowed shame and guilt to keep them distant from the

Father. However, when ladies would allow us to pray with them, it was such a beautiful moment. Their feelings of shame would begin to melt away as we confidently approached the Father together, even in the red light district.

My time in Amsterdam is not the only time I have seen women believing this lie. Whether we have a lifestyle of sin or have compromised in a small area of life, the enemy will try to attack us with shame and guilt. One morning after waking up, I allowed my feelings to control my response to God. Instead of obeying His voice, I decided to take the easy route that day. If we're being honest, we have all done this. Has God ever whispered something in your ear and you tried to act like you didn't hear it? Or maybe you did what I did and reasoned yourself out of it. If you have, you're not alone! We have all made mistakes and been disobedient. However, that disobedience does not affect the Father's attitude toward you.

Although I could easily justify my behavior, I knew I was disobedient and felt ashamed. I did not follow what the Lord wanted me to do and I regretted my actions. The shame caused me to distance myself from Him. Since I was disobedient, I assumed the Father was upset and planned on punishing me. He interrupted me in mid-thought and asked, *What kind of Father do you think I am?*

His question stopped me in my tracks and revealed my thought pattern. Since I was faithless, I assumed He would mimic the same attitude. In that moment, His mercy swept over me. He opened my heart to the truth that He is a good Father. Furthermore, He was not seeking to punish me, but He wanted to train me. He wanted to move me forward from this moment, not keep me in shame. Daughter, the mistakes you have made do not define you. He is not waiting around the corner to trip you or scare you. The Father stands right in front of you with open arms ready to embrace your dirty elbows and scarred knees. When you bring your failures before Him, He will cleanse you, not with tap water, but with the blood of Jesus.

In fact, it even says in Psalm 103: 12 (NLT), "He has removed our sins as far from us as the east is from the west." He does not hold your sins against you. He doesn't keep a filing cabinet full of all your mistakes. When He sees you, He sees a daughter who is washed and redeemed in the blood of Jesus. No matter which lie you may believe about the Father, you can always combat it with Scripture. The Word of God is powerful and it will provide a right perspective on the heavenly Father.

The heart of the Father is beautifully portrayed in Luke 15. Many of you may be familiar with this passage, so I will summarize it for you. Jesus tells the story of a father who divided his wealth between his two sons. The youngest

son, after receiving his inheritance, ran away from home and wasted his inheritance on loose living. Eventually, he found himself living among the pigs and quickly realized being home with his father was much better. As he gathered himself up from his mess, he carried guilt with him as he journeyed back home. The son believed he was not worthy to be accepted by his father again. He thought if maybe he was lucky, he could be his father's slave. However, the father's reaction perfectly displays the beauty of grace and acceptance. It says in Luke 15: 20-24,

> So he got up and came to his father. But while he was still a long way off, his father saw him and felt compassion for him, and ran and embraced him and kissed him. And the son said to him, "Father, I have sinned against heaven and in your sight; I am no longer worthy to be called your son." But the father said to his slaves, "Quickly bring out the best robe and put it on him, and put a ring on his hand and sandals on his feet; and bring the fattened calf, kill it, and let us eat and celebrate; for this son of mine was dead and has come to life again; he was lost and has been found." And they began to celebrate.

He didn't send the son back to his mistakes and keep him at an arm's distance. Notice that the father didn't

list off all the wrong decisions his son had made. In this story, you find Jesus describing a father's love that overlooked failures. The father didn't focus on what his son had wasted, but he decided to celebrate the one good decision his son made. Was the father in this story disapproving or ashamed of his son? No. Did he believe his son was a mistake and his life was purposeless? No. Did the Father overwhelm his son with guilt and remind him of all his mistakes? Definitely not.

The father in this story is a direct representation of your Father in heaven. The Father does not judge you based on your merits. No matter what your past may look like, you can still receive the same love He showed Jesus. Whether you've been away from His presence for a while or spent time with Him yesterday, He is so excited when you return to Him! When He sees you directing your heart back to Him, the Father runs toward you and embraces you. It is so important that you recognize the lies hidden in your heart keeping you from the Father. Once you identity those beliefs, come before His presence and ask Him what He thinks. I can guarantee you the Father will not fill you with guilt; instead, He will cover you with love.

The world may try to paint a picture of what the Father is like, but you must know Him for yourself. The relationship you build with Him holds power to transform

your mind and future. Lies will only keep you bound, but the truth will set you free!

Questions to Ponder:
1. Which lies do you identify with the most?
2. What past experiences lead you to believe those lies?
3. Spend time addressing those past hurts and ask God to give you a healthy approach and response to your pain.
4. Ask the Father to shine truth in your heart. Mediate on Him and write down anything you hear Him say.

Chapter Six: Crowned from Him

Building a lasting relationship with the Father requires destroying lies and understanding the concept of being a daughter. If you are a woman, you are automatically someone's daughter—that simple concept can also be applied to the kingdom. If you are a Christian, you are automatically the King's daughter. You might have heard this your whole life, but have you ever really believed it?

While I was a student in Bible school, a professor I highly respected came to me and spoke life over me. Without knowing the unbelief in my heart, he declared, "You are called to move in royal places."[1] This one sentence completely changed my perspective and opened my eyes to see how I was settling for less. I knew the Father loved me, but I had not accepted my position as a daughter. I believed I was called to be a servant in the house of God, and not a dearly loved daughter. Daughters are held at higher standards because everything they say and do represents their Father. With the responsibility of being His daughter, you are also given royal opportunities. These opportunities may not provide an earthly crown or require you to extend a gold scepter, but they call you to march forward with boldness. You can only do this when you accept your royal position.

Ruth was a woman who pursued her calling as a daughter. According to Jewish tradition, Ruth was a Moabite princess and was accustomed to the idol worship in her land. However, her whole life changed when she married a man with Jewish beliefs. As she grew closer to her new family, she adopted their faith as her own. When her husband suddenly died, her faith was put to the test. She could either run away with bitterness, or choose to cling to God in her pain. Instead of living with fear and disappointment, she remained steadfast and true to God's leading.

Her mother-in-law, Naomi, advised Ruth to stay in Moab as she traveled back home to Israel. Instead of remaining in her own country, Ruth remained loyal to the family name by following Naomi and looking after her. Ruth left what was comfortable to follow Naomi who renamed herself as "Mara" which translates as "bitter" in the Hebrew language. Not only was she following a self-proclaimed bitter woman, but she was also putting her own future on the line. The possibility of remaining single as a foreigner in the new land was very real. Ruth's decision also meant she must accept a new lifestyle as an Israelite and form a new community. She did not pursue her own desires, but Ruth trusted in her Father and revealed the heart of a daughter.

When God spoke through Naomi and encouraged her to show the ultimate sign of boldness, Ruth did not cower away. Naomi asked Ruth to approach Boaz and ask him to be the family redeemer and allow Ruth to carry on the family name. Instead of running away from this bold request, Ruth courageously went to Boaz's threshing floor and lay at his feet. Because she was confident in her God, Ruth laid down her pride and fear of the future, along with her heart. Her act of obedience not only produced a new husband, but also paved the way for her children to be in the lineage of the Messiah.[2]

Since Ruth was established in her position, she was strengthened with divine boldness. She knew her authority as a daughter, and pursued God's blessings for her life. Ruth did not avoid God, but she confidently walked forward assured of the Father's approval. Though she no longer had a physical throne, she moved in royal places for the first time. Her faithfulness was not only seen on this earth, but it also caught the attention of heaven.

Before coming to the Jewish faith, Ruth seemed to have it all. She was living in royalty and held a high position among the Moabites. She was beautiful, all her physical needs were met, and others knew her name. Although she was apparently living the dream, she forsook it all for the opportunity of knowing the true King. After

becoming a widow, the depth of her faith was revealed when she continued to remain faithful.

Since she let go of an earthly kingdom, God gave her a heavenly one. Instead of desperately clinging to a temporary crown, she allowed God to give her a crown that would never tarnish. In fact, her new crown produced the greatest glory this world has ever known, Jesus. Her position as a daughter and princess in His kingdom gave her gems in her crown that will always be remembered.

You may not receive a physical crown, but as a daughter you have the inheritance of an eternal crown. You stand as a princess in His kingdom. The crown He extends to you is the symbol of His beauty. Each moment you grow in His love and grace, your crown shines brighter and sparkles with radiant gems. Your crown will never look exactly the same as anyone else's. Since you are unique, the Father offers a crown of His beauty that is specifically designed for your head. This means you have the opportunity to reveal parts of His beauty that no one else could! That amazing truth shows how personal and thoughtful the Father is to His daughters.

When you walk with the assurance that you are His daughter, you gain ground in the spiritual realm. Just as Ruth walked with God's favor, you have the opportunity to see heaven open before you. Ruth would have never known she was destined for heavenly fame if she didn't accept her

role as a daughter. Being a daughter of the King is not just a catchy phrase, but it holds the power to unlock hearts. Just like in any earthly kingdom, a princess holds a powerful position because of her father. In the kingdom of God, a daughter is given authority and anointing to walk in her God-given purposes. A daughter who belongs to the Father isn't required to act like society, but instead, she transforms society in all areas of her life.

You don't have to qualify to be His daughter. You don't have to look the part and be the most courageous leader. Simply receive His grace, call Him your Father, and hear Him echo "daughter" back. If you are a child of God, He already sees you as His daughter; you just need to receive the truth in your heart. You belong in His family and He adopts you as His own. When you operate out of royalty, you can detect between the real and the fake. You can also have a higher perspective and know the secrets of the kingdom. Since she could discern between true royalty and temporary fame, Ruth laid down her life for the real thing.

The enemy is fully aware of the power and strength daughters of the King receive. I believe nothing scares the devil more than when he sees women understand their identity in the Father and unite together to bring His kingdom on earth. Since daughters hold a place in the kingdom, the enemy will do anything in his ability to limit

their influence. If he can get you to avoid the Father out of shame and fear, he knows your life will not be nearly as effective. Without knowledge of the Father, daughters sell their inheritance and settle for normal life. You were not designed for merely normal life; you were designed to operate out of your position as a daughter!

Being a daughter welcomes the sense of belonging. True daughters are not frantically running around hoping to find a safe home. Daughters in the kingdom know the only true home they will ever have is in their Father's house. Since I am an earthly daughter as well, I know from experience that my father will provide for me. Because I have spent time developing a relationship with my dad, I know his personality and what interests him. I don't have to come to his house afraid, but I know his home is more complete when I'm there. When you enter into the Father's room, He is delighted that you have come home! The great thing is you don't have to leave. As a daughter, you have the privilege of remaining with Him every day.

When you dedicate time to be with your heavenly Father, you recognize your role as a daughter while also learning His role as a Father. Knowing the distinction between the two sets you free from the burden of trying to do every task. If you step into your role as His daughter, your hands will be opened as He offers you joy, peace, and true life.

It is never too late to build a relationship with the Father. He is gentle, patient, wise, and full of grace and mercy. He has deep dreams for your life and you will only come to know those by seeking Him. When you were created you were designed for intimacy. You were not only conceived in intimacy, but He longs for you to walk in intimacy every day of your life. It is not necessarily a physical intimacy, but a deep spiritual one that is rooted in your relationship with the Father. When you go through your day, He is there. He is always right beside you and He desires for you to be aware of His presence. The Father wants to open your eyes so you can see yourself as the beautiful and powerful daughter He designed you to be. Catch ahold of this verse found in Ephesians 2: 17-18 (HCSB), "When the Messiah came, He proclaimed the good news of peace to you who were far away and peace to those who were near. For through Him we both have access by one Spirit to the Father."

Whether you identity yourself as the faithful son or the one who ran away and wasted it all, He still accepts you. Because you share in His name, you can experience full access into His presence. If you know your position in His kingdom as a daughter, everything can change. You can see life differently and realize you no longer have to strive for approval. The more you find your worth in the Father, the less you have to fight for earthly beauty. When you walk

hand in hand with the Father you have a living beauty inside that can never be stolen. He is a beautiful and always perfect Father. I know He has a special place reserved in His heart only for His daughters. Your name is grafted on His heart and His thoughts are focused on you. He paid the ultimate price so you could experience His presence. He laid it all on the line for you!

When you gain a right perspective on the Father, you can receive breakthrough in your life like never before! Having a revelation of the Father provides the acceptance that each one us desires. You can walk through life knowing Who you belong to and invite others on the beautiful journey of being with Him. By being His daughter, you can experience and walk in His divine beauty any moment of the day.

Are you hungry for more? Do you desire a deeper beauty than the tainted version the world offers? Do you need the beauty of His grace and love? You can have all of that if you allow Him to hold your heart. In His hands, your life is restored and is awakened to purpose.

Daughter, He is calling your name and is extending an invitation to you. On this invitation, it reads, "Will you come away with Me?" Don't place this invite on the table and say you'll respond later. Dare to trade your earthly crown for the one made of real gold. Run after the King,

meet Him in His throne room, and experience the beauty of His presence like never before!

Questions to Ponder:

1. What was your earthly father like? Did you feel loved and accepted by him?

2. What misconceptions do you think you believe about the heavenly Father? Are you afraid or ashamed to approach Him?

3. What do you need from His presence most of all? Maybe it's love, grace, healing, affirmation, or just a Father who will accept you.

4. Imagine yourself alone with the Father. What would you tell Him?

Spend a few minutes and wait for the Father to speak. When He does, write down what you hear:

The Son

A Light in Darkness

I never would have thought at nineteen years old I would be standing in refugee camps on the border of Thailand and Burma. Poverty, brokenness, and despair surrounded me on all sides. The Burmese sought to find refuge in Thailand and attempt to put the broken pieces of their lives back together. Children running around through the dirt were acquainted with the terror of their homeland. They had restless nights as they feared the possibility of recapture and returning back to Burma. Not only were they fearful, but most of the refugees had no knowledge of Christianity (they were accustomed to the idol worship in their land).

Children as young as three and four had only known hungry bellies and fearful minds. In the midst of their need, the Lord brought me to represent Him to these people. My team and I shared Bible stories, played games, and made crafts with the children; however, one unexpected event impacted me the most. While children were running around, I grabbed some nail polish and bent under a tree as I painted little girls' nails. Young girls would admire the pretty nail polish as I cleaned their hands and brought color to their world.

Girls would giggle and smile at one another while I spoke a foreign language to them. The young girls beamed

with excitement as they felt beautiful for the first time. They were not overlooked, but they felt noticed and appreciated. The attention they desperately craved had finally been met and they continued to cling to my side. Painting those little fingernails was planned by God Himself. Jesus looked down and knew each of those little girls by name. The Savior of the world knew each story, each mind, and each dream within every child I met.

Because Jesus is a friend to the lonely, He used my steady hand to make these girls feel loved. Even in the middle of a dangerous refugee camp, Jesus came and met with these precious daughters. Not only did their hands look prettier, but they also received a spiritual blessing from their Father as I prayed for them. When Jesus enters a space, everything changes. Hearts are awakened, hope is restored, and identities are found when people connect with Him. Jesus brings light to a dark world by becoming a friend and Savior to us. Throughout the gospels, Jesus would continually stop for the least likely person. If Jesus walked the earth during this time, I believe He would devote special time to the Burmese refugees. He would bend down, make the women feel beautiful, restore strength to the men, and bring healing to the whole camp.

If you identity with the refugees and feel like your world has fallen apart, take heart because Jesus is near. No matter where we find ourselves today, He is only a breath

away. In fact, His sacrifice on the cross paved the way for us to truly know Him. Jesus is the greatest adventure in this life and I am asking you to join this journey with me.

Chapter Seven: The Wilderness Jesus

There was a time in my life when I felt surrounded by wilderness. I wasn't in a literal desert, but my heart felt so dry and raw. I found myself with a broken heart, broken dreams, and feelings of loneliness. I longingly glanced at others' lives and saw thriving relationships and it seemed like all their dreams were coming true.

In my head, the enemy would whisper, *You're all alone. No one likes you. You've done something wrong.* Unfortunately, I entertained those lies for a while and believed I was all alone, journeying through the wilderness. I would cry out to God with my questions and fears. Whether I was in my car or sitting in my room, I couldn't stop the tears from streaming down my face. I felt so lost, so confused, and so forgotten. I followed His direction for my life, but it seemed like I had received nothing in return. My plans didn't turn out how I hoped and I didn't form friendships as fast as I wanted.

This season was tough, and many times I believed it would never end. I felt so stretched and I knew God was calling me deeper. No longer could I hold on to approval from others as my security. I knew He wanted me to empty my hands, so He could give me something greater. Was it scary? Absolutely! Did I feel unsure at times? Of course! Through the help of the Holy Spirit, I courageously dared

to give Jesus my whole heart—even my changing emotions, my doubts, and my fears.

What Jesus did next completely changed my life. He rid me of everything, so He could give me the most precious gift in life. He gave me friendship with Himself. It wasn't the kind of friendship that catches up with each other once a month. And it wasn't a one-sided friendship either when you receive nothing in return. It was a deep friendship that healed my wounds and set me free. In the times when I felt so lonely and empty, Jesus would whisper, "I'm right here." When I felt overwhelmed by emotions, He would tenderly speak to my heart and remind me He is always faithful.

Before I knew it, I considered Jesus my best friend. I knew if I needed encouragement, He was only a whisper away. In this season, Jesus showed me He is constant time after time. No matter how high the waves may crash over me, Jesus can still walk on the water. Also, no matter how lonely I may feel, Jesus sticks closer than any earthly friend. What seemed on the outside as the worst season of my life transformed into the most essential. The truths I grasped during this time could never be replaced with anything else. At first it appeared like a barren season lay before me, but it quickly turned into the most fruitful and fulfilling.

Who would have thought a wilderness season could also be the most romantic? Not me! No, I didn't receive

flowers at my front door or invitations for fancy dates, but I experienced the deep love of Jesus. His love wooed me and always called me deeper into intimacy with Him. He would speak to my heart and remind me of His plans for my life.

Song of Songs 8: 5 perfectly describes the result of drawing close to Jesus, "Who is this coming up from the wilderness leaning on her beloved?" The days I felt like stopping and throwing a pity party, Jesus pushed me forward. When I felt weak and believed I couldn't endure another day, Jesus held my arm and gave me strength. Within a matter of months, I was leaving my wilderness season. I noticed new fruit in my life like never before. This new fruit was not produced from walking in the wilderness. This fruit was produced from walking in the wilderness *with Jesus.* A lot of people can walk through tough times without the Lord. However, if you rely on Him, it not only becomes much easier, but you also witness more growth.

In every challenging situation, Jesus invites you to lean on Him. The Lord does not send you on a journey by yourself, but He promises to go with you. Hand in hand, you can walk through any desert with the Messiah. Every time you say yes to His guidance, He will lead you to mountain peaks while also demonstrating His grace in the valleys. He will show you streams of living water and continually guide every step you take. Jesus is all about the process and journey of life. He is not intimidated by miles

of wilderness, but He sees it as an opportunity to pull you closer. Jesus is so committed and faithful to His daughters. You have been created for a real and an alive relationship with Jesus Christ. I love the verse found in 1 Corinthians 1:9 (AMP), "God is faithful (reliable, trustworthy, and therefore ever true to His promise, and He can be depended on); by Him you were called into companionship and participation with His Son, Jesus Christ our Lord."

Yes, that verse is about you. You are called into fellowship with Jesus! You are designed to be friends with Him. There are some friendships in my life that make perfect sense. My girlfriends and I connect and completely understand each other. Since the relationship feels so natural, I can't imagine not having them in my life. God not only planned certain friendships for you, but He also designed you to desire a deep relationship with Jesus.

There are some days when my emotions are chaotic and make no sense. Some of my friends might be able to understand, but Jesus already knows every emotion I feel. I don't have to explain myself to Him, because He already understands every anxious thought in my heart. He also knows exactly how to address my needs and speak peace over me. He knows exactly what to say and how to say it.

Jesus knows your heart better than you know it yourself. He knows your personality and passions better than you could ever comprehend. When He speaks, His

words literally create life within you. If He knows you in such great detail, then this is a friendship you must have. Jesus really is the best of all best friends. Jesus Himself said in John 15:15 (HCSB), "I do not call you slaves anymore, because a slave doesn't know what his master is doing. I have called you friends, because I have made known to you everything I have heard from My Father."

The Savior of the world wants a friendship with you! He does not consider you worthless, but He views you as priceless. It may seem silly for the perfect and spotless Lamb to want to be your friend, but that is exactly the truth. In His friendship, He will share the secrets to the kingdom and reveal the heart of the Father.

A committed friendship with Jesus is so beautiful. He is constant, doesn't hold grudges, and is always interested in your life. Jesus wants to see you succeed and walk in fulfillment every day. Also, you don't have to question His advice, because He is the way, the truth, and the life (John 14:6). He will never leave you. Even when other friends forsake you, Jesus sticks even closer. Without the faithful friendship of Jesus, I may still be walking in the wilderness. I would probably be dragging my feet as I wearily longed for fresh life. My throat would still be dry and thirsting for water while carrying the burden of isolation. My whole situation changed when I allowed Jesus

to walk with me. In fact, Jesus went to the wilderness, so I wouldn't have to remain there.

If you identify with my wilderness season, hold on. Jesus is coming for you! If you feel like you lack fulfilling relationships, Jesus can fill that desire while also surrounding you with a godly community. The Messiah not only understands your heart, but He can also hold your heart.

When you place your desires in the hands of Jesus and start walking with Him, you can experience the greatest fulfillment you have ever seen. The cross is a beautiful symbol of salvation to you, but it is also a personal invitation for a divine friendship. His friendship with you shifts seasons, rescues you from the pit, and places you on the path you were designed for. The friendship He offers you is not temporary or based on prerequisites. You can confidently gaze into the eyes of Jesus and feel His hands by simply reaching your hand out.

Jesus Christ stands before you and offers His grace. Leaning on His grace is the pathway for friendship with Him. As you come to know Him deeper, the more satisfied your heart will become. Your wilderness will become streams of joy at the revelation that Jesus, the Lover of your soul, declares you friend. He is calling your name and desires for you to experience the greatest relationship this

world could offer. How about we all take His hand and allow Him to be our best friend for the rest of our days?

Questions to Ponder:

1. Have you ever gone through a wilderness season? If so, what was the hardest part?

2. Who in your life has disappointed you and how can you forgive them?

3. What do you believe is the biggest hindrance blocking you from Jesus?

4. How can you move past the obstacle and meet with Him?

5. What do you need Jesus to help you with most right now?

Spend a few minutes and wait for Jesus to speak. When He does, write down what you hear:

Chapter Eight: Past the Crowd

All throughout the gospels, they show Jesus focusing on women. Although our current generation would not be moved by that, His generation did not fully recognize women's role in the kingdom. It was considered controversial to spend time with a woman in public, especially if she was not your wife. Jesus didn't allow the customs of His time determine how He related to people. Since He desired for everyone, even women, to know Him, He focused much of His attention on setting people free, despite gender. Instead of only meeting the needs of men, Jesus would repeatedly stop and show love toward women.

One of my favorite stories of Jesus encountering a woman is found in Luke 8:43-48,

And a woman who had a hemorrhage for twelve years, and could not be healed by anyone, came up behind Him and touched the fringe of His cloak, and immediately her hemorrhage stopped. And Jesus said, "Who is the one who touched Me?" And while they were all denying it, Peter said, "Master, the people are crowding and pressing in on You." But Jesus said, "Someone did touch Me, for I was aware that power had gone out of Me." When the woman saw that she had not escaped notice, she

came trembling and fell down before Him, and declared in the presence of all the people the reason why she had touched Him, and how she had been immediately healed. And He said to her, "Daughter, your faith has made you well; go in peace."

Imagine yourself in her shoes. This woman had been in pain for twelve years. According to commentary in the *Holman Christian Study Bible*, her flow of blood was most likely caused by menstrual hemorrhaging.[1] Her bleeding was so severe she lost strength to complete her daily activities. She was constantly cramping as she focused on her issue. No matter how hard she tried, she could never forget the constant bleeding in her body. Not only did she lose her energy, but she also lost the ability to bear children and fulfill her dreams as a woman. For twelve whole years, this woman had felt like she lost all power over her body and there was nothing she could do.

She went to doctors, spent all her money, and still could not find a solution to her problem. Her issue of blood caused her to be viewed as unclean and as an outcast in society. If she simply went to the market place or the synagogue, she was still labeled as unclean. I'm sure she had lost close friendships because people rejected her. When people saw her in the streets, they would look the other way and avoid walking beside her. Men knew if they

touched her, they would be considered ceremonially unclean as well.[2] She felt all alone and like no one cared. Her constant bleeding isolated her from everyone and people forgot her name as they titled her, "the woman with the issue of blood." Her whole identity revolved around her sickness. She not only felt pain in her body, but pain in her emotions too.

The Old Testament law described the regulations for those with a discharge of blood. Leviticus 15 declares women with this issue as unclean. Each day the woman continues to have a discharge, the furniture and people she touches would be considered unclean as well. Verse 27 (HCSB) says, "Everyone who touches them will be unclean; he must wash his clothes and bathe with water, and he will remain unclean until evening." Imagine being called "unclean" and having others avoid you for twelve years. Many people could not endure this kind of psychological isolation for twelve days, but she lived in this agony for twelve whole years!

She eventually got to a point where she wanted to give up. She had tried everything. But then one day, she heard of Jesus and His healing power. If it was true, maybe He could heal her. However, she thought Jesus would never touch her if He knew who she was and what kind of disease she had. He would be appalled at her sickness and others would mock her. This woman probably thought Jesus would

be angry with her because her touch would cause Him to be ceremonially unclean as well.[2] The only way she could receive His healing was if she quickly touched Him without anyone noticing. She was so fearful of His disapproval that she planned on not touching His skin, but quickly feeling the tassel of His robe.

So, the day came. She heard Jesus was in town and she knew this was her one opportunity. She practiced how she would merely touch the edge of his robe and run off. If she lingered too long, someone might notice her and embarrass her before the King of the Jews. Her biggest fear was that Jesus would notice her. When she witnessed the crowd surrounding Jesus, she knew He would never know.

Quickly, she ran behind him, reached out with her fingers, and touched his robe. She planned on quickly running away, but then Jesus stopped. He looked around the crowd and wanted to know who touched Him. While hiding behind the crowd, the woman could hear the disciples clearly explaining that many people have been touching Him. Dismissing the disciple's logic, Jesus explained He felt His power released.

While the woman was trembling, she noticed her symptoms were gone. She was no longer in pain, she felt restored strength, and she could tell the bleeding had stopped. Although she was excited, she feared Jesus. After

all, she was ceremonially unclean and she had touched the pure Lamb of God.

Jesus kept asking who had touched Him with faith. He would look around the crowd and when He locked eyes with her, she knew she couldn't hide anymore. Prepared to be mocked and accused before everyone, she fell at His feet. She tearfully shared her guilt and explained it was her last chance to be healed. Although she could feel the cold stares of the crowd, she boldly proclaimed that she received healing.

After sharing all her struggles in the twelve years, He tenderly raised her head and once again looked her in the eyes. He wasn't full of rage, like what she expected. He instead was full of mercy and delight. His eyes showed grace and spoke acceptance to her weary heart. She wasn't considered unclean in His sight, but He saw her as whole. Instead of rejecting her like everyone else, Jesus applauded her and celebrated her faith. He fully embraced her and gave His full attention to her. In this moment with Jesus, she had never felt more loved. She was accepted and noticed by the King. He didn't skip over her, cast an angry glance, or accuse her of wrong. He wasn't angry that she secretly touched Him either. He lovingly affirmed her worth, j while also healing her at the same time. In the presence of Jesus, she was qualified and considered clean. She had finally experienced the grace and beauty of the Messiah.

Pat Caren (actually, whom Hannah raved about — not coincidence)

This is healing balmb to my ♡, soul, Spirit, strength, mind — there is a reason I read this after meeting with

Not only did He call her "Daughter," but He also extended peace to her anxiety. He saw the worry and stress, and He brought rest to her heart. He fully accepted her without limitations. No matter what others' opinions were, He declared her righteous. Jesus placed a glorious spotlight on her and gave her permission to shine.

Out of all the people pressing up against Him, He spent time to recognize the one who needed acceptance the most. He recognized her need and could feel her desperation. The faith within her was absolutely beautiful to Him and He wanted others to learn from her example. She felt like she had nothing to offer, but her simple story of faith was eventually told to millions. Jesus absolutely changed this woman's life. He told her exactly what she needed to hear. He not only addressed her physical problems, but spoke to her heart too. Instead of being "the unclean woman," she was now, "the woman Jesus noticed." Twelve years of torment, pain, and embarrassment ended at the feet of Jesus! She could now fellowship with others, celebrate her womanhood, and live the life she was always created to enjoy. Everything about her identity changed from this moment forward. Her encounter with Jesus impacted her, those around her, and eventually everyone who would hear her story.

I believe if we could still physically walk with Jesus, we would see how slowly and deliberately He walked. He

wouldn't be in a hurry to perform the next miracle, but He would be sensitive to the needs of those around Him. He would stop and talk to the widow on the side of the road and the prostitutes on the street corners. His love was not selective. His love permeated atmospheres and shifted environments. When He walked through a town, He would leave a trail of peace and joy. You wouldn't see Him cast a disapproving glance at the hurting, but He would see them as candidates for healing.

Jesus didn't judge situations according to what He could see on the outside. He saw the root issues and the hearts of people. Looking at the woman with the issue of blood, He could have decided she was forever helpless and unclean. However, He looked past the physical realm, and saw faith and purpose. Not only did He see the strength within her, but He called it out and affirmed it.

Wherever you find yourself right now, Jesus sees you. He doesn't merely look at your surroundings, but He sees the desires in your heart. He sees the dreams you have been holding onto for years. Jesus sees the sickness you have been fighting and the marriage you have been struggling with. According to Jesus, you are not defined by your situation. The labels society places on you are not found in the presence of Jesus.

Jesus does not give up on you, even if you have been struggling for over twelve years. Even if you are considered

an outcast by friends and family, Jesus will stop everything and meet with you. In that story, Jesus was actually on his way to heal a young girl before she died. You would think saving a life was more important than healing a rejected woman. However, Jesus thought differently. This insecure and broken woman was just as important as a young girl nearing her death.

Despite the expectations and demands of others, Jesus stopped. He gave her His attention, healed her, and empowered her to change her life. You might not see Him in the physical realm, but Jesus is always walking beside you. No matter how lost and forgotten you feel, Jesus will always stop and meet with you. All you need to do is push past the crowd and touch Him.

I believe the enemy uses the crowd to keep women from Jesus. The crowd can be overwhelming and lead us to assume Jesus will never notice us. The contrary is true: Jesus is desperately waiting for a faith-filled woman to reach past the throng of people and touch Him. Even just touching the edge of His robe can heal your hurts. I dare you to reach out to Him. Reach out with expectation and desire. He will never ignore you, but He will always honor your touch.

You can absolutely approach Jesus! The blood He freely spilled wipes away your guilt and shame. You don't have to hide from Him with embarrassment. Through His

love and grace, He whole-heartedly accepts you. He sees every hindrance that tries to keep you from Him, and He still chooses you. In His sight, you are redeemed and set free. He sees you as a woman of God who is awaiting an encounter with Him.

Jesus, the King, the Messiah, the Savior of the world, is waiting for you. He has set the table and He is waiting for you to dine with Him. At this feast, He has everything you need. He has the companionship laid out, the healing ready for you to drink, and the acceptance you can wear proudly. All you need to do is enter in and sit down. Simply tell Him what you are hungry for and He will set it before you. While you partake of His goodness, He will sit right across from you, look you in the eyes, and repeatedly say, "I fully accept you." He sees you for you, and He still calls you chosen. I don't know of any other friendship like this! You are meant to walk hand in hand with Him through every season of life. Trust me, life is much more enjoyable when you do. So, what are you waiting for? Every excuse and fear bows before Him, as He invites you deeper. Go forward, reach out, and experience the love that fulfills every heart!

Questions to Ponder:

1. How do you identity with the woman found in Luke 8?

In every way, baby — you nailed it! Thank you Jesus for using Allison and Hannah's obedience!

113

2. What are some areas in your life that need a touch from Jesus?

3. Are there any wrong beliefs or fears keeping you distant from Jesus? If so, spend time addressing those.

4. Ask Jesus how you can push past the crowd and press into Him more. Write down what you hear Him say.

Chapter Nine: Found in the Vine

As a child of God, I believe we all have the desire within our hearts to do incredible things for the kingdom. We want to share the love of Christ, operate in His wisdom, and reveal His grace to others. That may look like opening an orphanage, counseling broken people, raising Godly children, or in my case, writing this book. The only way to faithfully reach those goals and still walk in love is through remaining in the Vine.

Only a few chapters before His crucifixion, Jesus tells His friends and disciples one of the most important lessons He could ever teach. He knew they were soon to endure the confusion of His death, the joy of His resurrection, and the persecution of sharing the gospel to others. Instead of encouraging them to stand strong by faith, He told a truth they would have probably never expected. In John 15:4-5 (HCSB) Jesus says,

> Remain in Me, and I in you. Just as a branch is unable to produce fruit by itself unless it remains on the vine, so neither can you unless you remain in Me. I am the vine; you are the branches. The one who remains in Me and I in him produces much fruit, because you can do nothing without Me.

Although Jesus was soon to leave this earth, He offered a lasting relationship to His followers. Just because they could no longer physically see their Messiah didn't mean they couldn't fellowship with Him. Through the help of the Holy Spirit, they were able to connect with Jesus any time of day. If they needed direction for their ministry or a voice of encouragement, Jesus was only a whisper away.

By establishing themselves in their relationship with Him, the disciples could joyfully fulfill their call to spread the gospel. If the disciples strived to live righteously apart from Christ, they would miserably fail. They would be tired and irritated as they relied on others to bring them satisfaction. Jesus knew apart from Him, the twelve men could never change the world like they were destined to do. Understanding human nature, Jesus repeatedly told His followers to remain in Him throughout John 15. He knew their emotions would wage war against them and others would question their faith. Without a solid resolution to find their identity in Him, they would easily fall away and give into the pressures of society.

The Greek word for "remain" in John 15 is *menó* which is translated as "to stay, abide, remain."[1] In other words, when the disciples' emotions desperately wanted to flee and resort to a much easier mission, Jesus told them to stay and abide with Him. It was only through remaining with Him they would endure the trials to come. If they kept

their focus on what they could see with their physical eyes, they would miss truth and knowledge. On the other hand, if they kept their eyes on Jesus, they could overcome any trial.

During the last three years of Jesus' ministry, the disciples had been exposed to miracles, demonic oppression, and words of knowledge. Though they often struggled with understanding what Jesus was trying to teach them, they eventually learned they could not always trust what they could see. However, if they stuck close to Jesus, even after His departure, they would have a heavenly perspective on all situations.

In addition to producing lasting fruit, Jesus also desired for them to rest in His love. When all they could feel was hate and disapproval from others, Jesus offered a love the world could never offer. In verses 9 and 10 (HCSB), Jesus states, "As the Father has loved Me, I have also loved you. Remain in My love. If you keep my commands you will remain in My love, just as I have kept my Father's commands and remain in His love."

The Messiah knew the secret to their success was remaining in Him and resting in His love. Apart from Him, His followers would quickly surrender their faith and be overcome with grief. With His help, they could confidently speak truth while also living with joy and victory. Above any relationship they could build with one

another, He knew their relationship with Him was vital for the coming days. The words that were spoken on this day might not have made a lot of sense to the men until later on. When the glorious moment of Pentecost and God's promise of the Holy Spirit descended, they were reminded of Jesus' words and the pieces of the puzzle started to fall together.

The invitation to abide with Jesus is not limited to the twelve men. Jesus freely invites you to remain with Him as well. Your life mission may not look like the disciples', but you are still called to fulfill a dream of heaven. Without a relationship with Jesus, you will only produce premature or temporary fruit. You will see glimmers of success, but without Jesus, you will be in a constant state of striving. However, if you allow Him to be your Vine and the Father to be the Vinedresser, you will witness abundant fruit!

The heartbeat of His teaching in John 15 is intimacy. Jesus knew true ministry would only be the overflow of intimacy with Him. Apart from fellowshipping with and knowing Him, your ministry will lack life-changing power. In fact, Jesus is not seeking your fruit—He is seeking you. When He fully captures you, the fruit is produced as a byproduct. John 15 is all about shifting your focus. Jesus directs you to hunger for Him, not for evidence of His power. Without His presence within you, your good works will never reach satisfaction and it will lack

authenticity. As a daughter, He is pursuing your heart, and wants you to pursue His in return. The intimacy you create through your relationship with Him is the best fruit you could ever produce. This fruit not only impacts this life, but also the life to come.

I find it interesting that Jesus used the illustration of a vineyard for His teaching. The vinedresser represents the Father and the vine is a symbol of Jesus. He then shows that every disciple of His is a branch. Without a vine, the branch would literally fall to the ground and never produce anything. The vine provides water and the needed nutrients to sustain life for the branch. The branch would never produce what it was created for without the life of the vine. Only through being connected with the vine and receiving the vine's strength will the branch be fruitful.

Also, without a vinedresser to tend the branches, the fruit would never reach their full potential. Through the pruning process, the vine is able to provide life to the branches. You will encounter the pruning process many times in your walk with Jesus. If you refuse to yield to His purging, you will limit yourself. When you allow Him to have His work in your heart, you are still connected to the vine. Just because you feel dead branches fall off doesn't mean Jesus has left you. Jesus is the vine who never dies or runs out of life. In the seasons when you feel Him refining you, take courage and know the greatest fruit is about to

spurt forth! He doesn't prune you to hurt you, but He does it to heal you!

Apart from being connected to the vine, you might be able to complete good deeds. However, if those good deeds are void of God's glory, they will be worthless. You will never be able to make a real impact on this world without the life of the Vine. Jesus Christ impacted this world so strongly that 2000 years later people are still talking about Him! You're not the Messiah, but you have the opportunity to be His hands and feet in this generation. You can only represent Him rightly by staying connected to Him every day. When you decide to remain with Him despite outward circumstances, you also learn His heart. You will hear His words and feel His heartbeat because you choose to walk closely with Him. Understanding His heart is a powerful tool in praying His plans over your life. In this passage Jesus also promised in verse 7 (HCSB), "If you remain in Me and My words remain in you, ask whatever you want and it will be done for you."

Not only does Jesus want to be your friend, but He also wants to see you prosper, walk in favor, and understand His power. The key to unlock Jesus' dreams for you is found in the truth of abiding in Him. In this intimate relationship, Jesus will reveal His plans for your future while also giving you the grace to obtain it. A Christian life marked by overflowing fruit is a Christian life marked by

the vine. This simple truth holds the power to completely revolutionize your life!

Jesus is your vine, and you are His branch. You might produce different fruit than the other branches around you because you have a specific fruit you are designed to produce. The only way to produce this fruit is through remaining with Jesus. Intimacy found in the vineyard is the most natural and fulfilling. No matter what you face in life right now, let it serve as an opportunity to stay close to Him. Your roots will be healed, you will receive His strength, and the overflow of your love for Him will be beautiful and lasting!

Your closeness with the vine will produce hope, wisdom, direction, and His beauty. The beauty of His steadfastness and passionate life will radiate through you as your heart is connected to His. The only way you can share in the beauty of the Messiah is by daily choosing to seek His heart and by continually leaning on Him. His beauty will produce joy in your own life while also inspiring those around you. When hungry souls come searching through this vineyard, they will stop at your branch and be refreshed by your fruit. They will know your fruit is grown naturally and is the real deal. Remaining with Jesus through every season of life is the best decision you could ever make. He is waiting in the vineyard for you, all you need to do is turn to Him. You have already caught His

attention and He is already full of expectancy as you choose to lean into Him. Sister, how about we experience the joy of a John 15 relationship with Jesus Christ?

Questions to Ponder:

1. Why do you believe Jesus shared the illustration of John 15 with His disciples?

2. What are some practical ways you can choose to remain with Jesus today?

3. Are there any areas in your life that you believe Jesus wants to prune and produce greater fruit?

4. Ask Jesus if there are greater ways you can connect to Him and produce more lasting fruit. Spend some time in prayer and write down what you hear Him say.

The Holy Spirit

Will You Trust Me?

I really love traveling, especially with the Holy
Spirit. In the summer of 2014, I joined a team in bringing
the freedom of the gospel to England and Ireland. While
staying in Ireland, I was overwhelmed by the bright green
pastures, rolling hills, and rich history. We walked through
cities praying and ministering to the Irish through street
evangelism. Each day continued to prove better than the
last as my team and I connected in stronger ways while
understanding God's heart for the country as well.

As the weekend slowly approached, I knew Sunday
would be an important day. I was given the opportunity to
teach in a small church Sunday morning. My experience
with speaking was very small; however, I knew God would
tell me exactly what to say. A few days before Sunday, I had
a message prepared and I eagerly anticipated sharing with
the congregation. I was confident in my speaking abilities
and I knew I wouldn't disappoint the church.

However, two days before I was scheduled to speak,
the Holy Spirit changed everything on me. The Spirit told
me I must use this opportunity to teach about Him, not my
well-organized three-point lesson. When I recognized this, I
initially wanted to ignore God's voice and follow what I
already knew. I thought if I simply taught from my
prepared notes, nobody would ever know God told me

otherwise. While I battled within myself, the Holy Spirit made everything so clear. He revealed that I was leaning on myself, while He desired for me to lean on Him. If I continued on in my own understanding, my message would be limited on who it would reach. On the other hand, if I partnered with the Holy Spirit, I would hear His heart and reach those who needed it the most.

So, I surrendered. I sat down with an open Bible and told the Spirit to lead me. Within twenty minutes, I had a whole new lesson written out and I knew it was from the heart of God. He told me to speak on the empowerment of the Holy Spirit and encourage the church to rely on Him for their strength.

Although I obeyed the Holy Spirit, I was still nervous as Sunday approached. I was aware of my desperate need of the Spirit's help. If He gave me this word, I wanted to deliver it the right way. I desired to be sensitive to His voice, even if He spoke the last minute. Sunday morning rolled around and I had butterflies fluttering all in my stomach. Worship wrapped up and I knew I was next on the agenda. As I was introduced and took my stand on the stage, I looked around the congregation and I felt an indescribable peace. I knew the Holy Spirit was right beside me as I shared His message. I progressed through the teaching while aware of the Spirit's empowerment operating through me. When I finished my message I allowed time

for personal ministry. Many in the congregation were reluctant to receive prayer as my team lined up along the front. As I waited for people to come forward, I looked over the crowd and one woman kept standing out to me. It seemed like every time my gaze drifted in her direction, a spotlight would shine on her. Instead of waiting for her to walk to the front, I made my way to her.

I asked if she needed any prayer and she boldly shared her grief and worries with me. The Holy Spirit led me through prayer by showing me pictures of how He wanted to move in her life. As I spoke out what I sensed from the Spirit, tears rolled down her face as she affirmed what was said. If I had never been sensitive to His voice and allowed Him to lead me, this woman might have never received personal ministry. The Holy Spirit not only gave me the words to say on stage, but He also gave me the words to say to this woman.

That's how the Holy Spirit works. He will often change your plans last minute, ask you to only rely on Him, and then empower you to do His will. Although trusting Him may seem uncertain at times, the outcome is always worth it. His goal is to strengthen the saints and if you adopt the same goal, you will never be disappointed. The Holy Spirit is the greatest leader, encourager, and counselor in this world. I am challenging you to trust Him in new ways and take His hand in your day-to-day life.

Chapter Ten: The Person of the Holy Spirit

When I envisioned myself attending Bible school, I pictured myself walking through grocery stores and seeing the miraculous unfold before me. Assuming my whole ministry would start in my first semester, I eagerly anticipated operating in more power. I entered into this season with an expectation for more. God definitely gave me more, but it wasn't the more I originally had in mind.

I thought I needed power. If I saw miracles on a daily basis I thought I would be closer to God. If the signs and wonders found in Acts followed me, then surely I would know God approved of me. I chased after abundant fruit without ever considering the root of it. Desiring to see the evidence of approval, I continually placed myself outside of my comfort zone. Evangelizing and praying with strangers were normal practices for me during my first few months. None of these things were wrong. In fact, I learned so much and witnessed many people experience God through my obedience. However, my intentions were in the wrong place.

I viewed the anointing of the Holy Spirit as evidence and fruit of God's acceptance of me. Much of my ministry was performed from an empty void inside of me. Every time a stranger shed a tear, I felt better about myself. On the other hand, when someone didn't understand or wasn't

interested in God, I took the blow personally. I quickly developed the habit of judging God's love for me by how powerfully the Holy Spirit worked through me. As you can see, I viewed the Holy Spirit as an opportunity to display power. I chased after His signs and wonders, but never stopped to hear His voice. Without knowing it, I was manipulating the power of the Holy Spirit to affirm my worth. However, God quickly showed me a deeper power I could have with the Spirit.

When many Christians consider the beginning of the Holy Spirit, they remember the disciples experiencing His infilling during Pentecost found in the second chapter of Acts. After receiving anointing from the Spirit, they went on to witness thousands come to Christ and saw many healed and restored. Seeing the fruit of their labor, it can be easy to assume the Holy Spirit is merely the evidence of power. The disciples couldn't physically see the Holy Spirit, so people might assume they didn't have a relationship with Him. They could see and touch Jesus, but the Holy Spirit was exactly that—a spirit. Before any gift of tongues or miracles took place, Jesus shared with them about the ministry of the Spirit. Jesus said in John 14: 16-18 (HCSB),

> And I will ask the Father, and He will give you another Counselor to be with you forever. He is the Spirit of truth. The world is unable to receive Him

because it doesn't see Him or know Him. But you do know Him, because He remains with you and will be in you. I will not leave you as orphans; I am coming to you.

Before the disciples knew anything about the power of the Holy Spirit, Jesus told them they would know the Spirit. Jesus wasn't referring to a simple knowledge of the Spirit's gifts, but knowing Him like they knew Jesus. In other words, Jesus wanted the disciples to be friends with the Holy Spirit like they were friends with Him. Just because they couldn't tangibly touch the Spirit, didn't mean He was any less there. To the surprise of the disciples, Jesus said it was actually better for them if He went away so the Spirit could come. Since Jesus was a man, He could only be in one place at one time. On the other hand, the Holy Spirit would remain and live in each believer at all moments. So, when the disciples needed help or advice, they didn't need to search for Jesus, but they could communicate with the Holy Spirit inside of them.

After trying to derive personal worth from the Holy Spirit's anointing in my life, something changed. I was sitting in a Tuesday night service as John Bevere shared his wisdom on the stage. No matter what had happened earlier that day, my focus was captivated by the words pouring from his mouth. He explained the most fulfilling aspect of a

believer's life—a relationship with the Holy Spirit. This relationship, he explained, didn't require operating in extraordinary power. The relationship didn't include striving or fighting for attention either. John Bevere showed that a relationship with the Holy Spirit is supposed to be liberating and the greatest adventure of a Christian's life.[1]

I remember my heart pounded as I heard the Holy Spirit speak to my heart. The Spirit revealed that He longed for me to walk with Him. Whether that journey included miraculous signs or simply hearing His whispers, the Holy Spirit desired for me to really know Him. He didn't want me to only know His power, but He wanted me to know Him as a Person. He wanted me to be acquainted with His voice, recognize His heart, and know His character. I quickly learned the Holy Spirit has a personality and He is grieved by disobedience. No one wants to be taken advantage of, so why would the Holy Spirit be any different?

When I realized the Holy Spirit desires relationship above power, my perspective shifted. I no longer had to fight for approval, but I could rest in it. Also, I didn't have to listen really hard to hear what God was saying, but I could have a natural conversation with the Holy Spirit. My goal quickly changed from being as powerful as possible to being as intimate as possible. With this new revelation I now desired to truly know Holy Spirit as God.

Holy Spirit is no less divine than the Father or Son. As His name says, He is a holy spirit. He doesn't make mistakes and He is the embodiment of wisdom. After hearing many Christians speak about the Holy Spirit, I believe He is the most misunderstood Person of the trinity. On one hand, some people chase only after His power. While on the other hand, some people ignore His existence. Neither one of these options is healthy. Yes, the Holy Spirit is powerful and miraculous, but He will never embarrass or hurt anyone in His methods. He will never bring shame or guilt either. Instead of covering you with shame, He brings conviction and truth to your heart. Not only does He see your actions, but He understands why you did them. I believe that is why the Holy Spirit is the greatest counselor you can have. You can trust what the Holy Spirit tells you because He is completely reliable. It says in John 16:13, "But when He, the Spirit of truth, comes, He will guide you into all the truth; for He will not speak on His own initiative, but whatever He hears, He will speak; and He will disclose to you what is to come." Everything the Holy Spirit speaks is directly from the heart of the Son and Father. He is your direct link to heaven! Since He hears the secrets of heaven, He will share them with you if you listen.

Do you ever have those moments when everything seems to click? Maybe you're in the car or getting ready for your day and then all of a sudden a thought comes to you

133

out of nowhere. The more you think about the thought the truer it seems to be. When the Holy Spirit speaks, that's how it is most of the time. The words you hear from Him often go beyond your own thoughts. His words surpass your situation and speak peace and direction in your heart. When He speaks, He extends a gift to you that you must unwrap.

Looking back over my college years, I had a much different experience than most college age students. I never participated in underage drinking, took any illegal drugs, had premarital sex, or any of the other activities most college kids are known for. Despite my seemingly clean slate, the enemy still tries to taunt me. The enemy will often whisper that I missed out on the "best times of my life." Or he may even deceitfully tell me I should have gone down another path.

When the enemy speaks these lies to me, the Holy Spirit always speaks louder. Tenderly the Holy Spirit comes and says, "Well done. You have done what I have called you to do." I could immediately deny the truth from the Spirit, or choose to embrace it. Embracing His words is like taking the wrapping off of a gift and seeing the treasure inside. The treasure awaiting brings freedom and joy. However, I can only receive that treasure when I hold His words and peel back the layers of the enemy's lies. The more lies I shed, the closer I get to the truth. Once you fully hold His

truth concerning your life, you experience the Holy Spirit's heart like never before.

Have I made mistakes the last few years? Of course! The Holy Spirit doesn't judge my value by my faults or struggles, but He sees the intent and direction of my heart. He knows I have left much behind in order to follow Jesus whole-heartedly. Also, the Holy Spirit doesn't reserve Himself for perfectionists. He actually longs to give Himself completely to those who are aware of their desperate need for Him—not a desperate need for His power, but a desperate need for Him as a Person.

When the Holy Spirit speaks these words to your heart, you can receive peace. It's not a peace that makes you feel good in the moment or causes you to temporarily forget about your situation. His peace changes your attitude and replaces your worry with Himself. The gifts that you receive and unwrap from Him hold the power to shift circumstances and open opportunities in your life. When you walk with Him, you are walking with favor and delight. You are also walking with insight, wisdom, and prophecy.

Every person on this planet craves relationships. Since the Holy Spirit is a person as well, He longs to establish relationships with each person too. He doesn't like to be skipped over or ignored, but He wants to be recognized and acknowledged, especially among the children of God. The Holy Spirit is the most beautiful

person in this world. When you come to know Him as a person, you taste and see real beauty. You also begin to recognize His voice and follow Him on the journey of life. Since He is God, He is committed to you and will not all of a sudden disappear. The intimacy you create with Him is safe, secure, and is guaranteed to last. The Spirit of Truth is a person waiting to reveal Himself to you! He asks you lay down preconceived ideas of who He is and let Him teach you about Himself.

Questions to Ponder:

1. What have you been taught about the Holy Spirit? When you think about Him, what words or images come to mind?

2. Are there any areas in your life that require the help of the Holy Spirit? What aspects of His character do you need the most (counselor, teacher, encourager, etc.)?

3. Have you been living your Christian life with the revelation of Holy Spirit as God?

4. Ask the Spirit how you can better know Him as a person. Listen to what He says and write down practical ways you can strengthen your relationship with Him.

Chapter Eleven: The Everyday Encounters

If the Holy Spirit is always with you, that means He is always speaking. When you relax in your room, go to work, or run errands, He is still with you. In fact, He wants to interact with everyone you see and speak to throughout your day. He has truth and revelation on His tongue that He is waiting to share with the person you come in contact with. If you hear His voice, every life you meet could be impacted.

Learning to recognize His voice is not hard, but it is a process. When I first devoted my heart to knowing the Holy Spirit, I would often go on "treasure hunts." These hunts did not end with treasure chests, but it involved the Spirit leading me to certain people. The main goal was to demonstrate the love of God to others and connect them with what the Holy Spirit was saying. Often times the Spirit would paint a picture in my mind of someone He wanted me to speak to or He would even draw my attention to a certain person in my sight. Before speaking to the person, He would either give me a word concerning their life or He would ask me to trust Him. There were times I would approach someone and the conversation did not go as I expected. Sometimes the person would feel unapproachable or they wouldn't identify with what I felt the Spirit was telling me.

In those moments, I could feel discouraged and determine in my heart I could never hear His voice. On the other hand, I could also stand back up, listen to His voice again, and remain obedient. When I guarded my heart against the doubts of the enemy, the Spirit always filled me with joy and gave me direction for what I should do next. Just as there were times when I felt like I misheard His voice, there were also times when I knew the Holy Spirit was speaking through me. During the moments when the Holy Spirit uses my words to speak to someone it makes every struggle worth it. If I never dared to try again, that person might have never received an encouraging word from the Holy Spirit.

One particular instance I remember was at a small convenience store. As I checked out my few items, I felt His love for the woman behind the counter. While she busily rang up the items, the Holy Spirit spoke and gave me insight into her life. Without questioning His voice, I told the lady, "I feel like God wants to tell you that you have not been overlooked. He sees your situation and He is about to step in and provide a way." As I released these words, I could sense His love in the room. I knew God had sent me in this store not to just purchase items, but to also speak into the life of this woman. I wasn't trying to impress her in any way. I simply wanted her to know she was noticed and loved by the King of Kings.

After I shared what I heard the Spirit speak, her eyes filled with tears and she started nodding her head. She didn't need to say much for me to know that the Holy Spirit was right. It wasn't Allison who saw the depths of that sweet woman, it was the Holy Spirit inside of me. Since I recognized His voice, I was able to share His heart. If I were never obedient in the previous opportunities, I probably wouldn't have had the courage to speak up in a small store. Each time you step out, trust His voice, and declare what He says, He speaks to those around you and prepares you for the next time. We are all continually on a journey of fine-tuning our ability to hear and recognize His voice. As we progress on this path, God pulls us closer to His heart for other people.

This example is very practical, but the Holy Spirit is also very practical. The Spirit doesn't display His power only in church services, but He is interested in the one-on-one encounters you come across every day. He cares about the person taking your coffee order, the person in the car next to you, and your neighbors across the street. You see, the Holy Spirit is always speaking. The question is not: Does the Holy Spirit speak to me? Rather you should be asking yourself: Am I listening?

A story found in Acts 8 describes Philip's eagerness to hear the Holy Spirit. Instead of allowing his own schedule and plans to determine his day, he opened up

room in his life for the Holy Spirit to enter. While Philip was preaching the gospel and witnessing many come to Christ, he suddenly heard the Holy Spirit direct him to a new city. If Philip's heart were guarded with his own wisdom, he would have never recognized the Holy Spirit's command. Since Philip was yielded in his relationship with the Holy Spirit, he was able to partner with God in advancing the kingdom.

In verses 26-27 it says, "But an angel of the Lord spoke to Philip saying, 'Get up and go south to the road that descends from Jerusalem to Gaza.' (This is a desert road.) So he got up and went." Instead of ignoring or doubting His voice, Philip rerouted his plans and obeyed. The moment the Holy Spirit spoke, the scene was already being prepared for Philip. Unknown to him, an Ethiopian eunuch was pondering over the Messianic prophecies found in Isaiah on the road awaiting Philip. God already had a man appointed for Philip to encounter. The Holy Spirit would not have spoken the command if He did not already have a plan established for Philip.

Once Philip reached the road, the Holy Spirit continued to direct him to the right person. As Philip approached the Ethiopian man, Philip was directed by the Spirit on what to say. It says in verses 30-31, "Philip ran up and heard him reading Isaiah the prophet, and said, 'Do you understand what you are reading?' And he said, 'Well,

how could I, unless someone guides me?' And he invited Philip to come up and sit with him."

As Philip obeyed the promptings of the Holy Spirit, he "opened his mouth, and beginning from this Scripture he preached Jesus to him" (v. 35). The eunuch heard the truth of Jesus and declared Him as the Son of God. Following his salvation, God provided water for baptism. Once both men left the water, Philip was taken by the Holy Spirit to Azotus to continue preaching the gospel.

Because His love is extravagant, the Holy Spirit will rearrange your plans just to minister to one lost person. You must walk through your day slowly while focusing your heart on His voice to see His dreams for your life fulfilled. Growing up I remember my pastor always ending service with saying, "Walk slowly." Each Sunday morning, he was asking us to forsake the common tendency to rush on to the next activity. If you slowly make your way out of the building, you will be able to engage in conversation with others in the Body of Christ. Walking slowly is not only reserved for church services, Jesus demonstrated a lifestyle marked by this mentality. When you leave your planner open for the Lord to add to, erase, and revise, you will be amazed at what He will speak to you.

Hearing His voice is not enough, for you must also obey for it to produce fruit. If Philip delayed in his obedience, he would have missed the divine opportunity of

sharing the freedom found in Christ. Philip heard His voice and immediately acted. Notice the Holy Spirit did not supernaturally take him to the road. Philip had to stand up, determine the right direction to go, and trust the journey would be worth it. It wasn't until Philip proved his heart of faithfulness that the Holy Spirit supernaturally carried him to the next destination. Since Philip was exactly where God told him to be, the Holy Spirit transported him to the next city. That is pretty remarkable, isn't it? If Philip never dared to trust God with his day, he would have never experienced the Holy Spirit's supernatural act.

Before the Holy Spirit spoke, Philip was preforming mighty works throughout Samaria and even witnessed those practicing dark magic receive salvation. Philip could have easily regarded his present status in Samaria to be too powerful and influential to forfeit. The simple command he heard from the Holy Spirit was not merely a bump in the road, but it was divinely orchestrated by heaven. Choosing to follow His voice, he left his comfortable place and arose to where God has called him to go. As Philip traveled his way to locate the eunuch, I am sure the enemy questioned him if he heard correctly. The enemy probably whispered that he was leaving something great in Samaria and wasting time on the road. However, his assurance of the Spirit's voice was seen when he boldly approached the chariot and spoke God's heart to the man.

This encounter might have only been a short detour for Philip, but it forever changed the eternal destiny of the eunuch. This man was searching for answers and longing for freedom from the law. He was weak, tired, and worn out from trying to earn God's approval. Since the Father loved this man so much, he rearranged Philip's day just to set the eunuch free. Philip's determination to walk through his day slowly led him to a divine appointment.

When God whispers to your heart to speak up to someone, He is giving you the opportunity to encounter a divine appointment. He is also extending His grace, power, and words to you as well. In the moment, it is so easy to feel fear and doubt, but you can rest assured that the Holy Spirit is right beside you. Just as Philip was directly led to the man in the chariot, the Spirit can directly lead you to the right person who needs to hear what you have to say. God is not overwhelmed with fear that you will say the wrong thing, instead, He is full of love for the other person. He knows exactly where they are in life and all their inner thoughts. Out of everyone in the world, He chose you to show His love to them. When you realize the honor He is entrusting us with, the choice to walk away seems much less enticing.

Many times, especially as women, we will see our destination and quickly route out the simplest way to get there. However, what we don't always see in our plans are

the potholes, pits, and hills awaiting us on the journey. We assume that if we stick closely to our own understanding, we will finally reach our goal. If we keep pursuing our own route, we will get frustrated when the first pothole trips us up. The Lord sees us stumble through our own paths and He faithfully calls us on His road. From a distance, it may seem like the valleys and hills on His path will slow you down. It may also seem like it requires more work and you will never reach your destination.

What we don't realize is that His path might have mountains to climb, but it is also accompanied with never-ending grace and faithfulness. His path refines your character and draws you closer to Him. On His path, your goal is transformed from reaching the destination to enjoying the journey. The truth is, His path is the only one that brings you to the destination and guarantees that you are still full of life and strength. His pathway is not exhausting or overbearing. His plans hold purpose for you and for those you pass on the way.

If you feel worn out and struggle to hear the Spirit's voice, examine which path you are on. Are you following God on His peaceful path or are you striving to reach your goal with your own understanding? If you identity with the path of striving, the solution is easy. You don't have to prove yourself to God for Him to accept you on His path. You don't have to walk all the way back either. Just as the Spirit

transported Philip to the right destination, God can bring you to His path in a moment. To make that jump, you must lay down your own understanding. You must also allow room in your heart for the Holy Spirit to redirect you. In your thoughts, it might seem His direction will waste your time, but look at the fruit of Philip's obedience. Philip simply trusted and witnessed the Holy Spirit do the work as Philip yielded himself to Him.

Whether you've been walking with the Spirit for a while, or have never experienced it before, there is grace. You have not been overlooked by the Holy Spirit; He sees you and eagerly wants to reveal His love for the world through you. Yes, He has chosen you to be His mouthpiece and reconcile others back to the Father. It is never too late to switch paths. Since you are a daughter in the kingdom, you have royal words running through your veins. You have a direct connection with the King through the Holy Spirit. As a unique woman in the universe, you have a special opportunity to reach people no one else may ever be able to reach. The Holy Spirit within you is powerful, victorious, and completely trustworthy.

I love that His grace is abundant! He does not shame you for missing opportunities or saying the wrong thing. Instead, He heals your unbelief, trains you to know His voice, and goes with you as you minister to others. As you can see, a relationship with the Holy Spirit is a

beautiful thing and His pathway is the best one you can travel down.

Questions to Ponder:

1. Who are some people in your life who need a touch from the Holy Spirit?

2. Ask God how you can represent Him to these people. He might give you words, pictures, Scriptures, or just simple encouragement to uplift them.

3. As you examine your walk with the Holy Spirit, what are some ways you can better rely on Him? Is He asking you to go somewhere, say something, or lay something down?

4. Continue to be sensitive to His voice and actively listen to what He says.

Chapter Twelve: Living Beauty

We've all been in classrooms, meetings, and if we're being honest, church services when the words spoken go in one ear and out the other. Sure we might hear the voice of the speaker, but our minds are focused on other matters. It's obvious there is quite a difference between hearing and listening. You might hear the leader speaking, but you're not listening to their message. In other words, you always hear the Holy Spirit speaking; you just may not know His voice. He doesn't speak with a loud booming shout; He chooses to speak with a soft whisper in your heart.

You could be hearing His voice all day long, but it's unfruitful unless you are actively listening. Once you tune your heart to recognize His voice, your whole day could change. I can't tell you how many times my emotions have felt anger or fear throughout the day. Maybe someone disrespected me, said a discouraging word to me, or maybe I'm just running late for an appointment. In those moments I can choose to listen to my emotions and follow the downward spiral that frustration takes me on, or I could choose to stop and actively listen to His voice.

When I pause and sit in expectation, He always speaks. It might just be one word, a picture He paints, a Scripture that comes to mind, or a flow of sentences. However He chooses to communicate with me is exactly

what I need to overcome my emotions. Instead of focusing on my anger while driving down the road, I am able to praise Him and redirect my focus. My negative emotions are replaced with His love and grace. My anxiety is replaced with His peace. My fear of the future is replaced with the assurance that He is always with me.

To live a life worthy of the gospel, you must listen to the Holy Spirit. Without Him, we are destined for failure while aimlessly following our emotions. Although God created our emotions, they can be manipulated by our sinful nature. When insecurity, jealousy, or fear controls how you react, you are in for a wild ride. It says in James 1: 6-8,

> But he must ask in faith without any doubting, for the one who doubts is like the surf of the sea, driven and tossed by the wind. For that man ought not to expect that he will receive anything from the Lord, being a double-minded man, unstable in all his ways.

If you decide the course of your life based on how you feel, you will be thrown in every wave while always ending up on the shore. However, if you direct your focus on His voice, you will walk on the water. Sure, waves will still come, but you will be with the original Water Walker. When you have a single focus, trust in the voice of the Holy

Spirit, and ask for direction in faith, you will receive from Him. The impartations you receive will give you the strength to overcome high tides and crashing waves. When you listen to His voice and choose to believe what the Holy Spirit says, you are empowered to fulfill your purpose. You can almost hear the cheers from the crowd in heaven as you take each step with the Spirit. The Spirit doesn't guide you in unnecessary directions, but He leads you with a goal in mind. At times you may not understand His guidance, but He always knows what He is doing.

After I graduated Bible school, I heard the Holy Spirit direct me somewhere I never expected. I chose to lay down my previous plans and listen to His voice. I packed my bags, loaded up my car, and moved away from my family. Since I was being obedient to His voice, I expected for everything to turn out perfectly. Within a matter of only a few weeks, I realized this season was going to be nothing like what I expected. I could easily look at my time and say it was wasted. I could even assume I heard His voice wrong. Once I finished the last page of that chapter, I looked back over the previous several months. I noticed the Holy Spirit set a pattern in my life. During those tough days, I no longer relied on the state of my emotions, but I developed the habit of leaning on the Holy Spirit. I believe if I had never leaned on Him, I would still be in that bare and dry season. I would also probably be bitter and resent God for

leading me there. Without hearing His voice, I would have allowed my frustrated emotions to form my perspective. Learning to lean on Him and listening to the Holy Spirit's counsel was the greatest lesson I learned during that time. I left that season full of joy knowing that He did not lead me there with empty plans.

Despite what your emotions try to say, the Holy Spirit is always the ultimate voice of truth. He knows exactly where you are and exactly where you are supposed to go. He sees you in the tough days, the best days, and all the days in between. You can rest assured in His counsel. He doesn't give you encouragement to temporarily fix your problems. His words are designed to create within you a dependency on Him. I love this verse found in 1 John 2:27,

> As for you, the anointing which you received from Him abides in you, and you have no need for anyone to teach you; but as His anointing teaches you about all things, and is true and is not a lie, and just as it has taught you, you abide in Him.

As a child of God, you are called to remain and live with the Holy Spirit. Every day you have the opportunity to learn from the Spirit's anointing. As I said in an earlier chapter, He is so much more than supernatural power. The Holy Spirit is a living and speaking Person and He craves

relationship with you! He is committed to you in every season of life and He has more than enough grace to give you.

When you build your relationship with Him, you start to move in true power. The power and anointing you see will be rooted in a love affair with Him. Your power won't come from a void in your heart, but it will be the overflow of your relationship with Him. You will know His voice and His heart, which will impact every area of your ministry. Instead of striving to prove yourself, you will know your worth and Who lives inside of you.

As you come to know the Spirit greater, you will start to unravel the beautiful facets of His character. He is gentle, patient, wise, and forever loving. His discipline seeks to refine you and show that He is working for your best interest. While the Spirit beautifully loves, He is also divinely powerful. He can heal sicknesses, diseases, minds, hearts, and those oppressed by the enemy. The Spirit is true power; He is not a temporary fix, but He is the real deal. No one on this earth, not even demonic spirits, are more powerful than the Holy Spirit. Do you realize the same Spirit that raised Jesus Christ from the dead lives in you? The Spirit not only holds the power to raise the dead, but He can also give life to your body as well (Romans 8:11).

Compared to the beauty of this world that fades away with each new season, the beauty from the Spirit

never ceases. His beauty cannot be compared to earthly treasures. His love and grace exceed far beyond the makeup aisles and the glamour of photo shoots. As you yield yourself to Him, His beauty will literally heal you on the inside while also beautifying you on the outside. When you walk in a room, people will know there is something different. Whether they recognize it or not, the Holy Spirit is radiating through you.

The reason you become more beautiful is because His love becomes your love. His wisdom becomes your wisdom. His grace and understanding become your grace and understanding. Partnering with Him is the best beauty regimen you can do. You will resemble His likeness and the world will recognize that divine beauty is the real beauty. The beauty you embody will not be left on this earth, but it will radiate in heaven as well. In fact, His beauty in you will bring heaven down to earth. Every moment you represent Him rightly, you are bringing a piece of heaven into the atmosphere. People will see and know true beauty is among them.

The Holy Spirit is waiting to take you on the most beautiful and rewarding journey of your life. He has faithfulness, divine appointments, and a deep relationship with Him awaiting you. All you need to do is open up your heart and ears to His presence. Don't allow the Holy Spirit to be the biggest unknown in your life. Let the Holy Spirit

serve as the greatest Comforter, Confidant, and Leader throughout the rest of your days!

The Holy Spirit is truly beautiful. His counsel, love, and grace transform your mind as you experience His heart deeper. He is the true representation of beauty on this earth! If you mimic His beauty, you will reflect the glory of heaven more and more. You are called to be divinely beautiful, and the Holy Spirit will teach you how!

Questions to Ponder:

1. What have you been taught about the Holy Spirit? Is it different than what the Word says about Him?
2. If you drew closer to the Holy Spirit, how would your life change?
3. In what area of your life do you need breakthrough?
4. Do you need direction or encouragement in your life?
5. Listen to what He says and write down what you hear:

Part Three: The Word

Chapter Thirteen: The Weapon of the Word

I have met many beautiful sisters in Christ who love Jesus, but they lack growth in a crucial area. They might go to church every week, listen to worship music, and even pray with others, but they don't know the Word of God. They might have learned Scriptures when they were little, but they are unaware of the promises found in Scripture.

It can be easy to dismiss the discipline of reading the Word. I know, I have done it before. When I first started Bible school, students were required to read three chapters of the Bible a day and five on Sunday. On the days I actually did complete the reading, I would pick the shortest chapters and quickly glance over them. Within those few minutes, I was checking social media and maybe even having a conversation with a friend. By the time I had finished, I had no idea what I had read and I definitely didn't hear God speak to me. Sure, I was reading the Word, but I was not learning and growing from the Word.

I would see others' spiritual maturity and wonder how they got there. I thought maybe if I spent more time in worship and always talked about spiritual topics I would dive deeper spiritually. Or maybe if I responded to an alter call I would grow spiritually in an instant. All of these actions took me deeper, but I felt like I kept hitting a wall.

I knew I was missing something. I knew God had more for me and I wanted to discover what that more was.

It wasn't until I recognized a stronghold in my life that I got serious about the Bible. God opened my eyes to the root of impurity in my heart. That impurity affected how I thought, talked, and treated others. I despised the fruit of the stronghold; I just wasn't sure how to deal with the root cause. So, I did everything I knew to do: I received prayer, worshipped with all my heart, and tried really hard to change my thoughts. I would gain a little healing and breakthrough, but I would always find myself back in the same spot a couple days later. Becoming frustrated with myself, I finally asked God what I should do. He told me to declare the Word of God over myself out loud every day.

At first I thought He was crazy. I pictured myself speaking empty words without any results. If I explained what God had told me to others, they would think I was insane and too spiritual. I thought since the words that came from my thoughts didn't change my situation, how could words written thousands of years ago be the magic touch? Yes, I believed the Bible was written by God, but I didn't truly believe it held power. However, the Lord started breaking down my resistance by allowing me to hear stories of others receiving freedom.

I heard stories of great leaders who struggled with a variety of issues. Some received complete breakthrough in a

moment at the altar, but most described the process they walked through. Whether they battled anger, lust, or unbelief, they found relief in the Word. By finding specific Scriptures that addressed their needs, they would memorize them and declare them over themselves multiple times a day. Sometimes it would take a couple weeks or even a few months, but as they continued declaring the Word, they noticed their hearts and minds becoming restored. Before they fully realized it, what used to tempt them and make them fall no longer enticed them. Receiving the freedom they needed empowered them to fulfill God's purposes. Not only were they empowered, but they also learned to feast in the Word of God daily.

Hearing those testimonies provided the faith I needed to believe in the power of His Word. So, I dug around in Scripture and found the truth I craved. I quickly wrote the verses down on index cards, always carried them around with me, and declared them over my heart every day. The impurity that seemed like a permanent filter on my thoughts was washed in His Word. The stronghold I thought would never break, fell apart at the seams as I trusted in what God has said. Through my perseverance, my mind was restored as my heart found the source of purity. From that moment on, I knew the Bible was true and held the power to change any situation. In fact, the Bible even describes itself by saying in Hebrews 4:12 (NLT), "For the

Word of God is alive and powerful. It is sharper than the sharpest two-edged sword, cutting between joint and marrow. It exposes our innermost thoughts and desires."

The gross strongholds that I felt could never be conquered were destroyed by the living Word of God. Without His Word, my struggles would have never been exposed. The great thing is the Word not only shines a light on your heart, but it gives you the tools to defeat the darkness. The Word enables, equips, and empowers you to walk in victory in every season of life. In my situation, the Word didn't steal my identity and transform my calling. Instead, the Word refined me by ridding my life of filth and reminding me of who I already am. The Word of God is not a waste of time and it is not useless. Every moment you spend in the Word, you are being renewed and strengthened, whether you feel it or not. The Scriptures are literally a breath of fresh air to your soul and they provide hope to your mind.

Not only do you need the Word for your sanity, but you also need it to fulfill your call. Whether you're called to ministry, the marketplace, or to the beauty of motherhood, the Word is applicable. Imagine a high school student dreaming of becoming a brain surgeon. After receiving his high school diploma, he couldn't walk into a hospital operating room and demand a job. The patients wouldn't want him as their surgeon either. Before he was ever placed

in a position of influence or stepped near a patient, he would need to receive proper training. His training would require years of studying and diligence. His path may not always be easy as he learns methods and skills. He may even encounter other students along the way who stretch and challenge him. Once he passes the exams, walks the graduation stage, and shows himself qualified is he finally placed in leadership.

A student must work hard and be adequately trained in order to be promoted to the next level. If she refuses to grow, she will never fulfill God's purposes for her life. The Christian life is no different. Whether you're seeking a position in leadership, the opportunity to mentor someone else, or serve as a light of hope to your environment, you must be trained. I'm not saying you must earn a Bible degree, but you must demonstrate a heart that is hungry to know His truth. Training is a lifelong process. Christ is not waiting for you to reach perfection, but He is desiring for you to really know Him and His Word. When you are equipped with the Word, you can teach sound doctrine and represent Him rightly to others.

Imagine if I walked right into full-time ministry without being cleansed by the Word. I would bring my own personal hurt, rejection, and impurity into my ministry. Since you minister to others out of the overflow of your heart, I would be ministering that hurt to others as well.

yikes.

Also, without knowing the Truth, I wouldn't be able to lead others into freedom. Scripture is the most powerful truth I can speak. To truly change others, you must be transformed and healed by the Word yourself.

In the Word there is purity. The more time you spend devoted to Scripture, the more He is able to purify you. Since God is holy and righteous, His words are guaranteed to be holy and righteous as well. The power of Scripture will clean your wounds, restore your mind, and prepare you for everything awaiting you. Before you can mightily advance in the kingdom, you must be purified by the Word. Purity of heart is the mark of a woman of God. When a daughter of the King steps into a room, she is designed to bring a trail of purity along with her. This purity is not found in striving, but it is produced by mediating on His redeeming words. Read this slowly, "All Scripture is inspired by God and profitable for teaching, for reproof, for correction, for training in righteousness; so that the man of God may be adequate, equipped for every good work" (2 Timothy 3:16-17).

To unlock the God-given dreams in your heart, the Scripture is the key. The key that you hold in your hand not only opens doors in your life, but it also directs you to the right doors. If you're confused on what direction to take, turn to the Word. Or if you face an opportunity, learn from the Word so you can seize the moment. When you feel like

God is being silent, listen to His voice ringing out in Scripture. Even if your exact situation is not addressed in the Bible, He will give you the wisdom you need when you read His Word.

The Word of God is beautiful because it is a direct representation of God's heart. Every book of the Bible is dripping with His grace, patience, and love toward His children. In the Old Testament, His righteousness and divinity is displayed as He wooed His people to Him. Even when the nation of Israel aimlessly wandered in the wilderness, the Word shows He was committed to His children. In the new covenant, His grace heals every broken heart. While describing the restoration found in Jesus, the New Testament empowers Christians to live a life worthy of the gospel while being filled with the Holy Spirit. As you can see, the Word is essential in building a powerful and intimate relationship with Christ.

Since we have the Word, we can discover who God really is and learn what He desires for us. The promises found in the Word are powerful, and you have the opportunity to seize them and claim them as your own. Declaring the Word of God over yourself each day will impact your own personal situations and others you encounter. His Word places you in the perfect position to hear His Spirit and encounter His presence. He will give

you direction for your day and impart divine wisdom into your mind so you can lavish it on others.

When you spend time mediating on His Word, you are literally dressing yourself in the Spirit. If you wouldn't walk out of your house without clothing on your physical body, why would you choose to expose your spiritual body? Your spiritual body meets opposition, temptations, and warfare every day. Without the covering of the Word, you are an easy target to the enemy. The enemy will whisper lies saying that you aren't good enough and he'll remind you of your mistakes. You can easily fall prey to his tactics i you don't protect yourself in the truth of Scripture.

In the Word, the Spirit is your personal stylist. The Spirit knows exactly how to dress you. He knows what you will encounter and how others will treat you. Through the Word, the Holy Spirit clothes you with strength and grace. In my own personal life, there have been countless times when the Spirit will bring a verse to my attention. He will then give revelation and insight regarding the Word. Within only a matter of hours, I will encounter a situation where that verse is the perfect source of peace. Instead of viewing my day through the lenses of anxiety, His Word offers hope as I stand on the revelation the Spirit gave me.

Imagine yourself marching into a battle without a weapon or any armor. I can guarantee you that you will be knocked down, beat up, and possibly lose your life.

Compare that unprepared soldier to one who has a plan, understands the enemy's weaknesses, and is equipped to fight. The second soldier is much more likely to win a victory because he is ready. Every book, chapter, and verse found in Scripture is a weapon in your hands. You don't use it to hurt others, but you use it as spiritual warfare against the enemy. When the enemy throws dart of jealousy, lust, or impatience at you, you can dodge the attack with your knowledge of the Word. When you take time to dwell on His Word, you are taking up your sword in the Spirit and preparing yourself for battle.

You see, the revelation found in Scripture not only protects your mind from attack, but it also guards your heart. Imagine a handsome man actively pursuing you. Everything may look right on the outside, but in your heart you feel unrest. If you know the Word, the Holy Spirit will use Scripture to provide the direction you need. Even when your mind doesn't know the answers, the Living Word will impart wisdom into your heart and will gently lead you. It even says in Psalm 119:105 (NLT), "Your word is a lamp to guide my feet and a light for my path."

Since I have spent time learning from Scripture, I am able to examine a situation through the lenses of Truth. If facts don't line up with His Word, then I know He has something better planned. Without the knowledge of the Word, you can easily settle for less. You can even choose

"good" options, but never experience His best plans for your life. God wants to clothe you with royal garments through His Word, and the enemy wants to clothe you with rags. God wants to empower you, while the enemy wants to devalue you.

In His Word, He reminds you of your identity and worth. He shows you that you are chosen and dearly loved. When you chose to clothe yourself with this Truth, you become a threat to the enemy! Instead of wearing shrunken rags, you are clothed in armor that can withstand any battle. The Word is essential in overcoming attacks of the enemy. Not only does it bring victory, but Scripture also leads you to your promised land. As the Word refines and strengthens you, it provides the courage you need to climb mountains and dream with the Father.

In this world, we encounter limits all the time. As women, we receive criticism from others, even from those closest to us. Maybe it was family members saying you could never obtain an education, lose weight, or find the right relationship. Or maybe it is even your own self who serves as the biggest critic in your life. Unfortunately, the worldly system looks at outward appearances and makes judgments. However, the Word sees your potential and call in His kingdom. Scripture knows you are called to big places and are positioned in this generation for a reason. The Word refuses to place you in a box. His Word is the very essence

of hope and it continually calls you higher, despite your feelings of inadequacy.

When you find refuge in Scripture, the boundaries fall down. You are no longer entangled by the world's requirements, but you are set free to dream big dreams with the Maker. The limits are eliminated as the Word empowers you to do the impossible. When you find your identity in Scripture, you are molded into the mighty woman of God He has called you to be.

We all want to live lives full of impact. Many have made earthly influence, but if you partner with His Word, you can move heaven and earth. The Word will cover you in His beauty as you mediate on truth. Each moment you chose to turn your affection toward Him, He is transforming you more and more into the glory of Jesus. In Proverbs 4:20-23 Solomon tells his son the importance of truly hearing. He says, "My son, give attention to my words; incline your ear to my sayings. Do not let them depart from your sight; keep them in the midst of your heart. For they are life to those who find them and health to all their body." No matter where you are right now, His Word is life for you. His Word will meet you where you're at emotionally and speak the truth you need the most. You must only devote your time, lean in, and learn from Him.

His Word is beautiful because it is a faithful friend and it is always constant. His Word will never change and

He watches over it. In fact, Jeremiah 23:29 even says God will make sure His Word is accomplished and completes its purpose. So, when everything around you seems chaotic, the beauty found in the Bible can serve as an anchor to your heart. The Word of God roots you, establishes you, and builds you up in Him.

The roots you develop in the Word can never been shaken. The further the roots grow, the greater abundance of fruit will be seen in your life. If you are a woman who craves to see God's purposes fulfilled in your life and refuses to settle for less, then you will grasp on to the intimacy found in Scripture. His Word is life, peace, joy, healing, and victory! Until you dive into the Word, you will continue to hit a wall in your depth with Him. If you face strongholds and battles, the Word is the only weapon that is promised to bring victory. Daughter, I dare you to reach for your sword and discover a whole new world of truth and freedom!

Questions to Ponder:

1. Is there an area in your life that you are struggling to overcome?

2. What does the Word say about your situation? Write down Scripture, memorize it, and declare it out loud.

3. What are some practical ways you can incorporate Scripture into your daily life?

4. If you don't know where to start, I recommend Ephesians 1. Spend some time reading through it and listen to His voice. Write down what you hear Him saying regarding your specific situations.

Part Four: Position Yourself

Chapter Fourteen: The Invitation of a Lifetime

As you have worked through the chapters devoted to the Father, Son, Holy Spirit, and the Word, I hope you have grown in understanding. Some truths you may have heard many times, or others may have been brand new to you. Whether you've received fresh revelation or strengthened your relationship with God, you are now presented an opportunity.

Imagine yourself dressing up in a beautiful ball gown and attending the most talked about banquet in the world. You could look around and see well-known people as you stand in the gorgeous room. Women and men are dressed in their best attire as you can feel the excitement in the air. You see long tables with crystal centerpieces accompanied with place settings each marked with specific names. Finding your name, you sit in expectation as each course is served. Upon the arrival of the first meal, you eagerly glimpse under the platter and see the most exquisite cuisine you have ever laid eyes on. You look around and spot some people chowing down on the tasty food, while others sit back and merely watch. Those who partake of the food start to glimmer in their faces and a light seems to be shining from the inside.

The more each person tastes the one-of-a-kind meal, the more they stand out among the crowd. Those sitting and

refusing to sample their meal develop feelings of insecurity as they watch others shine with beauty. Seeing the wonder in the room, you lift your fork and bring a small taste to your mouth. Not only is the taste heavenly, but you can also feel sensations in your stomach. A second taste begins to transform your mindset. The third taste causes you to view others through fresh lenses. As you finish the rest of your plate, your stomach feels full of food along with purpose. Assuming the dinner is over, you lean back and realize this has been the most fulfilling experience of your life. The anxiety you entered the room with has been replaced with peace and joy. The tendency to compare yourself to others has been overcome by the desire to uplift those around you.

Just as you get ready to stand up, leave, and remember the night as the best one yet, another platter is served. You remain seated and eagerly partake of the new delicious meal. Round after round of meals continue to be served as you taste new foods and experience new feelings within. This dinner never ends because the food never runs out.

The beauty of the trinity is on a magnificently crafted silver platter before you. You could look at it all you want, but it's not until you taste it for yourself that you really experience the life-changing meal. Tasting His beauty is not a onetime experience, but an ongoing feast. New facets of His beauty are constantly placed in front of you

and it's your choice to uncover more of Him or not. Like many guests in the room who only sat back and spectated, you could be merely inches away from understanding Him deeper and completely miss the opportunity. God is never late in delivering meals and He never overcooks anything. Each item He places in front of you is full of perfection, love, and life. His beauty holds the power to heal you of unworthiness and transform how you treat those sitting around you. Not only does this banquet hold the power to heal you on the inside, but the more you taste His beauty, the more you resemble it on the outside.

Notice the people never transform on the outside without partaking of the meal first. Before you can ever understand and walk in His beauty, you must chew on it yourself. Chewing on His beauty requires lifting the Word to your heart, seeing His character throughout Scripture, and filling your spirit with His truth. At times you may have feelings of uncertainty as you experience new tastes you have never tasted before. However, each new taste of Him produces new growth in your life. He will amaze you with grace this world could never fully offer. The world may try to resemble the silver platters, but it always ends up as unsatisfying microwavable meals. Yes, the world's method is quick and convenient, but His banquet positions you as royalty and fulfills your deepest desires. His banquet strengthens you and reveals your own purpose as you taste

more of Him. The quick and unsatisfying beauty from the world leaves your stomach rumbling for more as you judge the plates of others. The only real fulfillment of beauty is found in the glorious ballroom at your seat marked with your name.

The invitation is set out. The meals are already prepared. Your beautiful ball gown is awaiting you. Everything you need to experience His beauty has been put in place. Just as in the movie, *Cinderella*, the Holy Spirit can transform you into the best version of yourself. In an instant, He can clothe you in glorious splendor and boldly bring you before the banqueting room. All you must do is turn your affection toward Him, and allow Him to dress you in royal garments.

At moments, He may ask you to shed layers of pride, greed, lust, or even insecurity. Initially, you may fear the cold as you expose your wounds, but immediately He will doubly clothe you with the beautiful garment of grace. His style is weather-proof and perfectly prepares you for the awaiting feast. As you clothe yourself with strength and grace from the Spirit, He will introduce you to other women who are readying themselves as well. In those encounters, you can provide encouragement and offer suggestions so each woman will look her best. You are not alone in your journey, but your loving Father has already orchestrated what you will wear and who you will sit by.

This journey is not accomplished overnight, but it requires commitment, endurance, and an inner hunger for more of God.

Choosing to be vulnerable to the Holy Spirit is the first step in positioning yourself. Vulnerability can often be a scary word for many women. When we envision ourselves becoming vulnerable, we might anticipate rejection or embarrassment. Your thoughts may go back to hurtful remarks from family members, ridicule from students in school, or even women in the church who disqualified you. However, there is a difference from all those people and the Holy Spirit. The difference is that the Holy Spirit is God. If He is God, then everything He does is beautiful and perfect. The vulnerability I talk about requires opening your heart and allowing the Spirit to search the deep parts of you. 1 Corinthians 2: 10-12 states,

> For to us God revealed them through the Spirit; for the Spirit searches all things, even the depths of God. For who among men knows the thoughts of a man except the spirit of the man which is in him? Even so the thoughts of God no one knows except the Spirit of God. Now we have received, not the spirit of the world, but the Spirit who is from God, so that we may know the things freely given to us by God.

The Holy Spirit not only searches the depths of God's heart, but He also knows every hidden corner in yours as well. The reason He wants to search your heart is so He can expose lies you've believed and trade them for th truth. Did you know God has precious gifts He wants to give you? You can only freely receive His gifts by opening your heart and allowing the Spirit to make room.

After you take down your walls and let the Holy Spirit touch your wounds, you can then walk in truth. The truth states you are a woman of high worth. You do not deserve to be trampled on or overlooked. In the eyes of the King, you are one hundred percent royalty and destined for greatness in His kingdom. Believing the truth of God's Word about your identity transforms your approach to life. Instead of dressing yourself in rags, you can confidently wear the gorgeous one-of-a-kind gown He has handcrafted for you. Truth is the pathway for experiencing the fullness of God's goodness in your life.

The more you walk with God, the deeper measure of truth you will obtain. God is truth; apart from Him, you settle for a distorted version of truth. Your lifelong journey with God is a continual process of learning more and letting it all take root in your heart. You will not wake up one morning with a full revelation of every aspect of God's truth. To receive more truth, you must take notice of where

you place your feet and the direction you are going. Each step toward God requires more vulnerability and the willingness to let go of things contrary to Him.

Once you position yourself for the Spirit to search your inner beliefs and decide to receive His truth, you are then clothed with the beauty of God. Your appearance will be radiating with freedom, joy, and the understanding of your worth as a daughter. The more you allow the Spirit to dress you each day, the longer you will find yourself at the banqueting table, tasting the fullness of God. The jealousy you once felt toward women across the room can easily be replaced with the bond of unity. The feelings of unworthiness that once surrounded your heart can find peace when you boldly put the fork to your mouth. Even the despair and brokenness that once consumed your mind can find rest when you proceed to the second and third platter of His presence.

In the last three chapters, we will learn how to position ourselves. I will give you an opportunity to search your beliefs and allow the Holy Spirit to shine a light on your heart. After the Spirit fills you with truth, we will study the fruits produced in relationships and how we interact with those around us. Lastly, we will discuss the lasting benefits of a woman marked by the beauty of God. These last few sections could be the most crucial in your walk with God. Although our journey is coming to an end, I

challenge you to stay committed and continually allow the Lord to do a new work in your life.

Questions to Ponder:

1. When you imagine yourself at the banqueting table, do you see yourself partaking of the meals and receiving all He wants to give you?

2. If so, how can you encourage those around you to do the same? If not, what do you believe holds you back?

3. The Holy Spirit longs for us to be open and vulnerable to Him. As you read this chapter, what was the Holy Spirit speaking to your heart?

4. Allow Him to see the depths of your heart and speak truth. When you hear Him speak, write down what He says and mediate on His words.

Chapter Fifteen: Facing Your Beliefs

Have you ever sat in a teaching or a church service and felt inspired? But then you leave, forget the message, and never apply it to your life? I think we've all been there! What does it really require for a message to change your life? Is it three catchy points, a funny story, or an illustration? I believe all those details can definitely help hearers remember a teaching. However, I do not want you to simply remember my words; I want you to be able to apply them.

To apply truth to your life, you must examine how you currently live. You must discover areas of your life you struggle with and learn why you want to change. Learning the "why" is so important—without it you are only changing behavior without addressing the root issue. Your behavior is not produced from your reactions. Behavior is the overflow of your beliefs. If you believe you are not worthy, your behavior will continue to reflect that until you fill your thoughts with truth. For a revelation to truly impact your daily activities, you must stop, examine your beliefs, and fill your mind with truth.

Without a revelation of the truth, you will continue in the same cycle of insecurity. I have seen far too many women try to correct their behavior by simply telling themselves they will act a different way. You may try really

hard and even succeed for a while, but true freedom is not achieved without knowledge of the truth. John 8: 30-32 says, "So Jesus was saying to those Jews who had believed Him, 'If you continue in My word, then you are truly disciples of Mine; and you will know the truth, and the truth will make you free.'"

His Word gives you full access to freedom. Also, notice it says, "continue in My word," which shows that many times receiving truth is a process. The truth will always contradict the lies you have believed. When you meet that truth, you have the decision to either continue in it or become offended and walk away. As Jesus said, true disciples are those who accept truth despite the state of their emotions. Every time you press into His presence and read His Word, you receive more and more freedom!

Let me paint a picture for you. Imagine a woman desperately holding on to a plastic jewel. Since it looks real from a distance, she promises herself she will never let go of it. Every morning she wakes up, she grabs her plastic jewel, and she places it in her pocket as she goes throughout her day. When she goes to the marketplace or a friend's house, she feels her prized possession in her pocket and feels reassured.

One day, she encounters a jewel smith who displays his valuable jewels to customers. The diamonds that sparkle under the light reveal the dullness of her cheap plastic.

Others stop by the table and are struck with awe at the sparkle and purity of the jewels. As she compares the two jewels, she realizes what she has been holding on to is insignificant next to the real thing. The plastic replica she faithfully carried with her does not draw a crowd, nor does it shine up close. She discovers her plastic jewel holds no value next to a radiating diamond.

Seeing her wonder, the jewel smith decides to give her a brand new jewel free of charge. The only requirement is that she leave her plastic jewel on the counter and walk away with the diamond of great price. Debating whether she should trade her jewel for his, she slowly takes hers out of her pocket. As she studies the differences between the two, she hears the jewel smith say the real jewel holds much more significance. Hesitantly, she hands over her replica and receives the brand new weighty jewel.

As she takes her new jewel home and starts carrying it in her pocket, she begins to question the last few years of her life. Within a matter of a week, she quickly realizes she had wasted many years settling for a jewel that appeared promising from a long way off, but lacked shine in the palm of her hand. Her plastic replica never reminded her of her worth or made her feel beautiful. However, with her new jewel, she knew she obtained something that was truly beautiful and worthy. *Yes! So much symbolism. The ring I gave to Phoebe as a gift from God.*

185

The beliefs from the world may look extravagant from a distance, but they lack substance and authenticity up close. Far too many women carry a replica of the truth in their pockets, but never exchange them for the real thing. Because you believe your plastic jewel defines you, it can be hard to hand it over for something else. If this were a real life story, we would all think the woman was silly not to trade her plastic jewel for a much more valuable one. Although you can't physically see the lies you're holding on to, the same concept is true. Compared to the beauty of His Words, your beliefs produced by the world are completely dull and void of sparkle in comparison. The amazing thing is you don't have to qualify or save up enough money to purchase a brand new jewel. All God asks you to do is leave your old beliefs at His throne and receive His truth. When you fill your heart with His jewel, you are reminded of His delight for you and His purposes for your life. His truth will bring meaning, joy, and freedom back to your heart and mind.

Before any of that takes place, you must acknowledge the belief you have been carrying around. You must also have the courage to bring it before the King for Him to examine. He might approve of it, strengthen it, or give you a whole new belief instead. No matter what He says, you will never leave empty handed or shortchanged.

Your worth will always be enhanced in His presence and you will always receive an opportunity to walk in truth.

While you read this chapter, I want you to examine your beliefs and why you believe them. Maybe you believe you aren't good enough, have made too many mistakes, or could never fulfill God's plans for your life. We all have areas in our lives that we can improve, so there is no shame in your struggle. I am asking you to open your heart, investigate root causes, come before His throne, and make the great exchange.

Just as a pastor may offer an encouraging word on a Sunday morning, I have provided a word geared toward women. You could read my words, feel motivated, and then continue in your normal life. At the last page, you could simply close the book and focus on the next task. Or you could mediate upon God's heart and allow Him to transform you from the inside out. God provided the ideas for the words on these pages and they hold the power to set you free. However, you can only experience freedom when you let down your walls and let Him in. When He comes in, He shines a light on your heart, speaks truth, and gives you wisdom on how you should walk forward.

To allow His beauty to become a reality in your life, you may have to change your habits. You may also need to lay desires down and refocus your priorities. No matter what He calls you to do, He will give you the grace to obey.

I can't tell you what He wants you to do specifically, but th
Holy Spirit can. He will guide you into all truth if you give
Him room in your heart. Each time you decide to listen to
His voice, you are developing a plan of attack against the
enemy. His Words become a sword in your hand and give
you direction as you walk forward into the future. You are
also strengthening yourself to avoid falling into the traps
that many women fall prey to in their lives. His wisdom
makes your path clear as you carefully place your feet.
Listening to His guidance will bring peace and freedom to
your heart. Proverbs 4:25-27 (HCSB) declares this promise,
"Let your eyes look forward; fix your gaze straight ahead.
Carefully consider the path for your feet, all your ways will
be established. Don't turn to the right or to the left; keep
your feet away from evil."

To the right and to the left, you can find many
women stuck in the mud of despair or in the ditch of
comparison. Because they have not renewed their minds
and accepted His beliefs, they repeat the same cycle of pain.
The women on the path are marked by unity and a deep
trust found only in the beauty of the Lord. They are not
easily distracted or enticed by sinful lifestyles. Each time
they sense their earthly desires pulling them to the side,
they set their gaze on the face of Jesus. As they lock eyes
with the Messiah, He calls them further onto the straight

path. The longer you focus on God right in front of you the more room you give Him to operate in your life.

I will never forget the moment God showed me a picture of the path in my life. I saw myself at a fork in the road. On one side was a dark and winding path that lured its followers through lust and appeal. I know this dark path was going backward and there was no sign of life. Right in front of me was a different path with Jesus standing in the middle. The path directly in front of me was full of light and I could see down it for quite a while. I then heard Jesus say, "You decide." Jesus would never force me down His path, but it was so clear I would only experience peace and joy if I were with Him. If I followed Him, I knew I would be safe from harm and be in the company of the One I love. From that moment, my decision to stay on the straight path was easy. I didn't need to question what the other option could offer me. I knew everything I have been looking for was found with Jesus wherever He led me.

Since I believed He was trustworthy and would not lead me astray, I knew I could follow Him with my whole heart. Without that understanding, I would allow my emotions and my limited understanding to guide me. When you walk without a belief birthed from heaven, you are susceptible to a life stuck in the ditch. So, how do you become that woman walking on the straight path? Ultimately, you must align your attitudes and perspectives

to match His. Many times you will have to lay down your own personal agenda to receive His. The greatest way to achieve this is by spending time with the Lord every day and building a history with Him. Remaining on His path is only possible if you continually focus your attention on Him.

In my own life, on the days I skip out on my time in His presence, I am vulnerable to distractions and temptations. Because I have not renewed my mind for the day, I can very easily find myself in the cycle of insecurity and jealousy. My attitudes throughout the day can quickly revolve around the belief that I am self-sustainable and can rely on my own good works. If I continue in this belief, I will find myself in stress and an overwhelming amount of disappointment. However, each morning that I dedicate my time to Him, He reveals more of who He is and I am reminded that He walks with me. He also gives me the grace to overcome situations throughout the day with His guidance and peace. His presence reinforces the truth declaring that He is the One who makes me pure and righteous.

I'm sure we all want to walk in and experience His beauty—what we don't always realize is that a sacrifice must be made. You will need to sacrifice your time and preconceived ideas of who God is and how He should operate. You may even have to change the way you view

yourself and others. The good news is that every time you sacrifice your fleshly desires, your spirit is receiving fresh strength.

One of the best ways to taste and see His beauty is by meditating in His presence. In your times with Him, ask Him questions and hear Him respond. Be honest, real, and vulnerable with the Lord. He is not afraid of your questions, mistakes, or fears. The more you expose your heart to Him, the more He will expose His beauty to you. Along with spending time with Him, it is so important to guard what you allow your eyes to see and your ears to hear. The times in my life when I struggled with comparison the most were also when I allowed myself to watch television shows and movies promoting sinful conduct. Although I told myself grace covered my habit, what I failed to realize was that I was literally feeding my spirit what my eyes watched. It goes the same for music as well. I am not saying you can only listen to Christian music, but I am saying keep yourself on guard and examine what you are feeding your spiritual body. If you become infatuated with sin, you will quickly find yourself on that dark path I mentioned and you will miss the purity of His presence.

The Holy Spirit is a great friend who will check your heart when you are slowly slipping off the path. He will speak quietly and tenderly to your spirit. If you tune into and obey His voice, He will train you on how to stay

191

on the straight path. It may not always be fun to accept His discipline, but I can guarantee you every sacrifice is worth it. The Holy Spirit's mission is to prepare you for the kingdom on earth and in heaven. Christ not only desires this for the church, but for every woman as well:

> Husbands, love your wives, just as Christ also loved the church and gave Himself up for her, so that He might sanctify her, having cleansed her by the washing of water with the word, that He might present to Himself the church in all her glory, having no spot or wrinkle or any such thing; but that she would be holy and blameless. (Ephesians 5:25-27)

Every time God challenges you to lay down a habit or wrong behavior, He is washing you. When you allow His Spirit to have full access to your heart, you radiate the glorious beauty of His presence. He does not wash you only for His own delight, but He washes you for your delight as well. A woman stuck in the mud may avoid the stickiness and smell for a while, but eventually she will feel the filth and desire to be clean. To be clean, she must leave the ditch and be washed on the pathway.

You see, the women on the side of the road didn't find themselves in a ditch overnight. No, it was a little

compromise that eventually spread throughout the rest of their lives. Maybe it started with inappropriate music that led to lustful thoughts, which gave birth to addictions, which brought her to a sinful lifestyle. It all starts with a seed and the more you water it, the more it grows and produces fruit. What areas in your own life live in the mud of compromise? It doesn't even have to be a horrendous or unbelievable sin to keep you captive; it could very easily be anxiety or fear. Even if you don't live an active sinful lifestyle, it does not mean the enemy will stop tempting you.

I learned this concept when I was in a very busy season of life. I was a full-time college student, working a part-time job, writing for a magazine, serving at my church, and completing many hours of volunteer work each week. As you could guess, I was constantly exhausted and stressed out. Finally, I reached a point when God asked, "Did I tell you to do all this?" I sat there in silence and the Lord said, "The enemy has tricked you into doing many good things, but I did not call you to do them." From the outside, I looked like a superhero, but on the inside I was falling apart from anxiety and weariness. That was not God's plan for me. My thoughts revolved around the belief that I must work for approval. My wrong belief was focusing my attention on myself, and not on God's grace. When I received His truth, my whole outlook changed. He whispered, "Just because you're busy, doesn't mean I

haven't called you to peace." That truth impacted me greatly as I realized that I had been settling for a lie.

With God's strength I was able to reexamine my motives and kindly say no to opportunities. When I allowed God to organize my time and activities, I received the peace I had been praying for. I was also able to achieve way more than I had beforehand. I believe many women, especially those in the church, are fully acquainted with the cycle of busyness. We run here, there, and try to solve everyone's problems along the way. We might even have a pure heart while doing it, but if God has not placed the situation in front of you, there is no reason to go off the path.

I know this may be hard to believe, but the person or situation that is not on our path is on someone else's. If you were called to do everything then God would not have created me or any other person in this world. When you allow the enemy to distract you with good things, you miss the best things God wants to give you.

We will never live a flawless life, but Christ has given us the empowerment to lean on Him during times of testing. His Spirit will give you the strength you need in the exact moment you need it. But it is your choice to accept His help. Even when you mess up, His blood purifies you and calls you holy. The moment you realize and believe you are righteous in Him, your focus transforms, which leads to transformed behavior. 1 Corinthians 1:30 (NLT) says,

"God has united you with Christ Jesus. For our benefit God made him to be wisdom itself. Christ made us right with God; he made us pure and holy, and he freed us from sin." Daughter, you are no longer a slave to sin, but a slave to righteousness (Romans 6:18). You are fully equipped to change the way you think about yourself. You have not only been called to a holy, pure, and fulfilling life, but the Holy Spirit will bring you there, if you follow Him.

The Holy Spirit has a unique plan for your life and I believe He wants to show you! He longs to reveal to you how He sees people and situations. When you see from His perspective, it becomes much easier to act loving and show His beauty. Aligning your beliefs with His is the key to the greatest breakthrough in your life. How about we put these words into actions? What if we really asked God what He thinks about us and the situations in our lives? I can guarantee you we would all receive fresh hope and be able to follow Him without fear.

In my own life, one of the most beneficial fruits of receiving truth has been my interactions with others, especially other women. I used to constantly compare myself to other ladies and complain when I felt they excelled more than me in an area. If I believed another woman was more attractive, smarter, had more friends, or received more attention than I did, I immediately assumed I had been defeated. Instead of seeing relationships with other women

as opportunities of sharpening each other, I saw them as competitive games. However, in this game, no matter what did, I always ended up with the shorter stick.

In the next chapter I will discuss how we interact with women. This can be a tough subject for many ladies as they remember broken relationships in family, messy friendships, and women who have made them feel worthless. As you remember specific faces, you may have to face unforgiveness or bitterness in your heart. Remember when God asks you to do something, like forgive someone or pray for them, He always gives you the grace to complete it.

At times, it may feel like your heart is a ball of mess, but the Spirit knows exactly how to sort through each offense. If you understand my previous struggle and often times view women as the enemy, then healing is about to be found under the platter. Before we jump into this topic, I want you to remember to allow the Spirit to search your heart. He may bring specific women to mind who have hurt you or maybe even highlight women in your life who you can encourage. Continue to be sensitive to His voice and humble yourself under His truth. He does not expose your heart to hurt you, but to set you free—how wonderful is that!

Questions to Ponder:

1. When you think about yourself, what words come to mind? Write those words down.

2. I now want you to ask God the same question. "Father, what do you think about me?" Write down what you hear Him say.

3. Secondly, ask Him if you believe any lies. Ask Him to pinpoint a specific belief.

4. Then, pray He reveals His perspective on that belief. Ask "Father, what is the truth?" After hearing His reply, pretend you are holding your belief like the woman with the replica of the jewel. Picture yourself before His throne and leave your belief at His feet. You will not leave robbed of anything, but ask the Lord to replace your wrong belief with His truth. You are now fully equipped to carry the truth into your daily life and experience freedom in your thoughts and behaviors.

Chapter Sixteen: The Uniting Power of Women

Throughout elementary school, my classmates and I would often play the game "Red Rover." We would split into two teams, face each other, and lock arms. Each team would take turns calling classmates from the other side. Once your name was called, you would run toward the line of the other team with all your strength to try and break through their arms. If you broke through their grip, you would then join their team. The game would continue until everyone's arms were bright red from pressure and one lonely person was left on the other side. Although many of my friends loved this game, I hated it. Not only would my arms get hurt, but I also hated trying to break through the other side. It seemed like no matter how fast I ran, I could never successfully break my classmates' firm grip. When people would run toward me and my neighbors, we would brace ourselves knowing pain was about to come.

This whole game was very simple. The goal was to break down the other team with your strength. Unfortunately, as women, I don't believe we leave this mentality on the playground. We pick up this mindset and carry it with us in our home, workplace, and in our friendships. We deceitfully believe if we can prove to be more powerful, we'll gain approval and win. However, the more we try to prove ourselves, the more people get hurt in

the process. As women, we strive for perfection whether it's in appearance or performance. The more highly we are respected; we assume the greater worth we will achieve. When we feel strong enough in ourselves, we run toward other people with our words and reactions. If we successfully prove to be better than the other person, we feel more qualified in ourselves. However, as outsiders view this game, it all looks like a waste of time. The players are only attacking one another and hoping to win somehow. When you're in the midst of the playground, this game seems like the only option. Whether you play this game yourself or know someone who does, I am asking you to take a step back for a moment and consider a different option. Take a look at this word written to Thessalonica from Paul in 1 Thessalonians 5:14-15 (AMP),

> We [earnestly] urge you, believers, admonish those who are out of line [the undisciplined, the unruly, the disorderly], encourage the timid [who lack spiritual courage], help the [spiritually] weak, be very patient with everyone [always controlling your temper]. See that no one repays another with evil for evil, but always seek that which is good for one another and for all people.

Nowhere in that message does it say, "Seek to break down other people and show yourself stronger." No, it says, "always seek that which is good for one another and for all people." This letter to the city of Thessalonica was geared toward new believers, as Paul sought to encourage them and give direction on how to live a godly life. Most of the fresh Christians were Gentiles and were not accustomed to serving one another with unconditional love. Before coming to Christ, they adopted the world's mindset of looking out for their own personal gain. However, when they received grace and salvation from Jesus, they were expected to live a much different life. This new life would not come automatically, but they needed to be taught and trained in how to serve God. Although the Apostle Paul wrote this letter hundreds of years ago, I believe if he were still around today, he would write a similar letter to this current generation. There have been far too many times I have overheard women bickering and cutting down one another with their harsh words. Sometimes it's not even their words, but their glares can be just as hurtful.

It's not only women in friendships and families, but we judge women we see in public as well. My eyes were opened to this epidemic as I was trying to mind my own business in the gym one day. I was working out when my focus was interrupted by the woman next to me on the machine. As each woman in front of us walked by making

her way to the locker room, this lady would mumble curse words and verbally cut down the stranger under her breath. At first I assumed I heard her wrong, but she continued shooting hurtful arrows at women. Although these women could not hear the words spoken toward them, the atmosphere shifted. I could sense a heavy weight of insecurity and bitterness in the air. If I closed my eyes, I could almost feel like I was watching a game of Red Rover. Each idle word spoken by this woman next to me was damaging the strength of others. Her words would cut through them and leave a deep mark.

When I sensed this shift, I felt weakened myself and escaped from the situation. Though I was only around this woman for a few minutes, I could not forget what happened. Her bitterness and rejection were burned in my heart as I realized she was hurt herself. Instead of trying to avoid her in the gym next time, I actually prayed God would place me right beside her again. Only a couple weeks passed until I found myself hearing her words a second time. After repeatedly hearing her judge other women, I decided to speak up. The Holy Spirit gently led me into creating a conversation with her. I simply asked for her name along with other basic questions. By the end of my workout, the Father gave me a prophetic word for her. I looked her in the eyes and told her she was not forgotten by God and He has called her by name. Tears immediately

filled her eyes as she realized she was already loved and adored by heaven.

Through speaking these words full of hope, the atmosphere shifted again, but it was a much more pleasant shift. The spiritual atmosphere was no longer permeated by defeat, but I could sense a spirit of acceptance rising up. She no longer verbally criticized other women and she peacefully completed her workout. From this moment, I realized women have two options. We can either tear down or build up. Every time you encounter another person it presents an opportunity to represent jealousy or love. Far too often we listen to our changing emotions and stand on the foundation of insecurity. Since too many women try to balance themselves on shaky ground, they desperately hold onto anything they think will bring stability. Maybe they hold on to wealth, the latest fashions, or their qualifications. These choices may seem trustworthy at first, however, when another woman steps up, they start fighting for their position.

Daughter, let me tell you something that holds the power to set you free. You were never designed to fight for a position or a place. You don't have to push yourself to climb the mountain of success. This world may look for a ranking, but the Father looks at your heart. In fact, the blood Jesus spilled already established you in an unshakeable kingdom. In His eyes, you are chosen, called, and qualified.

When I was walking through a time of restoring my identity and shedding insecurity, the Lord led me to truth that changed everything. Colossians 3: 1-4 (NLT) beautifully says,

> Since you have been raised to new life with Christ, set your sights on the realities of heaven, where Christ sits in the place of honor at God's right hand. Think about the things of heaven, not the things of earth. For you died to this life, and your real life is hidden with Christ in God. And when Christ, who is your life, is revealed to the whole world, you will share in all his glory.

If your new life is found in Christ, then your identity and purpose are resting at the right hand of God. At His right hand, there is no comparison, emptiness, or jealousy. His kingdom is marked by righteousness, peace, and joy in the Holy Spirit (Romans 14:17). When you realign your focus toward kingdom goals, you will realize there is no need to compete with other women. As a daughter of the King, you are destined to share joy with other sisters. Although we are destined to sharpen each other, the enemy tries to convince us of the opposite. The enemy knows if he can trick women into fighting each other, they won't notice the fight from the kingdom of

darkness. Through deceit, the enemy sells lie after lie, hoping women will never reach true peace among themselves. So the question is: What is the source of the chaos and mess in women's hearts?

I believe women are not satisfied. After chasing endless trails promising worth and acceptance, we stop midway and realize we aren't fulfilled. Since many women are not walking in the beauty of the King, they settle for temporary fixes. Once their momentary solution wears off, they desperately search for a woman to step on so they can reach higher. It then begins the constant cycle of judgment and sizing up other women. If you recall from the first chapter, women are designed to feast on and reflect the beauty of God. When women don't fulfill that design, the sins of envy, pride, and rude conduct are thrown into their lives. The enemy quickly turns what was meant for extravagant beauty into a game where there is no clear winner.

I know I have focused a lot on women at war against themselves; now let's study the result of unified women. If a team of insecure women holds power, imagine how strong they would be if they joined hands and worked for the same cause. No matter what storm came, they continued to uplift each other and push each other forward. This team of women would not be easily defeated or distracted, but they confidently marched into any battle and claimed victory.

My desire to see a community of women was not born overnight. Instead, this vision and dream were birthed out of a moment of testing in my life. In this season, everywhere I looked it seemed like other ladies were graduating, becoming engaged, scoring the perfect jobs, and building incredible friendships. However, when I looked at my own life, I felt alone and confused. For a while I dwelled on my lack and envied everyone else, but then God spoke to my heart. While hearing the news of another engagement, the Lord tenderly said, "Celebrate her and be truly happy for her." After wrestling with His command, He opened my eyes to truth that healed my broken heart. The heavenly Father said, "This woman's success and fulfilled dreams do not steal your own personal worth in any form. Nor does it make My promises for you any less trustworthy. Just as I worked in their lives, I will work in yours, if you learn to celebrate other people."

From this moment my attitude shifted. I no longer focused on my own interests, but I was strengthened to recognize God's faithfulness in other women's lives. Not only did I become a greater blessing to others, but this shift also enabled me to cast my concerns and fears on Him. By celebrating other people, it actually set me free! I practiced this command in my daily life by taking friends out to lunch as I listened to their hearts spill over with joy. Instead of turning the conversation to revolve around my

concerns, I rejoiced and celebrated in their lives! When I adopted this new mindset, I strengthened my friends while also strengthening myself. I was no longer trying to prove myself or break their grip, but I lovingly locked arms with them.

Each time a woman decides to focus on the concerns of other women, she is building up a community of women. As more women join, the army of mighty women grows. The more women who unite together, the greater the potential of victory over attacks of the enemy.

So, what if you dared to unite with other women? You're not only called to join the ranks of women of God, but also the women who feel forgotten or too lost in sin. Through encouragement and mercy, you can call these broken women up higher to find their lives in Christ. That is a life worth living! The longer you allow your identity to rest in Jesus, the more you can experience His beauty. When you exchange your shortcomings for His glory, you will be given the most precious gift of all—His beauty inside of you. When you choose His beauty and then lead the women next to you to do the same, it can become a domino effect. Eventually, each woman will be burning with a beauty so contagious that it fills rooms, families, and generations to come!

Women full of confidence and integrity don't waste their time attacking other women. These women who have

direction are working toward a goal and they don't allow distractions to get in the way. The women who are known by God don't settle for anything less than what He has planned for their lives. I can guarantee you insecurity and jealousy are not in His plan. His thoughts for you are geared toward peace and unity with others.

When I consider the women in my life who have impacted me the most, many faces come to mind. I see my beautiful mother who trained me in walking with God. I see my pastors' wives who have labored over me in prayer and offered guidance in my life. I also see teachers from school and mentors who listened to my heart and encouraged me. Every single one of these women did not seek her own advancement, but she chose to regard my life as important as her own. Each of these women has sat with me, wiped my tears, disciplined me, and given me hope for the future. Because they decided to uplift me and strengthen me, my life has been transformed. Without their support, I might not be standing where I am today. Since they demonstrated love toward me, they will receive a reward from the fruit produced in my life.

Even the women who walked with Jesus during His ministry were all united. Since women were not as respected as men during the time period of early church, I find it very interesting the gospels mention the support of women multiple times. Instead of passing them over, the Holy

Spirit placed a special focus on these women and allowed millions to read of their faithfulness. Luke recorded in his gospel account,

> Soon afterward Jesus began a tour of the nearby towns and villages, preaching and announcing the Good News about the Kingdom of God. He took his twelve disciples with him, along with some women who had been cured of evil spirits and diseases. Among them were Mary Magdalene, from whom he had cast out seven demons; Joanna, the wife of Chuza, Herod's business manager; Susanna; and many others who were contributing from their own resources to support Jesus and his disciples. (Luke 8:1-3, NLT)

Do you realize without the support of women in Jesus' life, His ministry would have looked a lot different? This team of women, though often overlooked by others, was regarded as crucial to the Messiah. Although they all worked toward the same goal, they represented various backgrounds. Some were delivered from demonic oppression and even left their upper class families behind all for the sake of Jesus. They did not push their way to the front of crowds or boast in their freedom, but they served together. When one of them was struggling, they would surround her

with support and encourage her to keep pushing forward. Their decision to work together and give what they could not only strengthened themselves, but also Jesus and His disciples. Their unity was so powerful that Jesus even revealed his resurrected body first to Mary Magdalene and operated through her to spread the Good News to the disciples.

When women of God resemble the lifestyle of these ladies found in Luke, they can make a tremendous impact. Though Jesus is no longer physically on this earth, the Holy Spirit is moving, breathing, and speaking every day. In fact, the Spirit is searching for communities of women who will serve together and represent the heart of Jesus. The Holy Spirit is delighted and excited when He sees women lock arms, unite, and leave comparison on the side of the road.

Contrary to what your emotions may try to say: You don't have to qualify and hold certain prerequisites to serve God with other women. You could even come from a background of demonic involvement and still leave a legacy! I believe something so special happens when women decide to show acceptance. The impurity that once covered hearts is washed in the water of love. As women realize their identity in the Lord, they are equipped to fulfill their task in the kingdom. You are not called to a temporary impact, but through His beauty you can create an atmosphere that

catches the attention of heaven! As the Father looks down and sees women lit with His passion, He will meet with them and reveal Himself even more. The kingdom of God is not only consisted of church leaders, but it highly involves women who are filled with and empowered by His presence.

Did you know that women hold a special place in the heart of God? When He created women He deposited a part of His character within them that only a woman can reveal. The more each woman recognizes that portion of Him within her, the more she can reflect His glorious beauty. If one woman can completely overwhelm the heart of the Father, imagine how a whole army of women impacts His heart. I can see Him dancing and rejoicing with women as they celebrate victory. I see Him leaning toward each woman while listening to her heart's desires and telling her His deep wonders. Whether it's two passionate women or a whole room full of His daughters, all of heaven stops and delights over the beautiful sight of united women.

Women who decide to strengthen each other, despite the sacrifice, make a huge impact in the spiritual realm. Don't let your life go on without experiencing His plans for women. He wants to see you walk in fulfillment and then walk in fulfillment with others as well. Unity is a characteristic of God and it is a beautiful sight when women adopt it as their own. So, how about we leave the

silly games on the playground and march into battle together?

Questions to Ponder:

1. Have you ever been hurt by women? I know we all have, so there is no embarrassment!

2. What steps can you take to forgive those women and walk in God's grace?

3. Spend a few moments in prayer and ask the Lord to place a woman on your heart. What are some practical ways you can connect with her and fight together?

4. What can you offer within a community of women? We all have gifts, talents, and passions that can be utilized for His kingdom. Ask the Lord what your role may be and write down what He says.

Chapter Seventeen: A Real Beauty Mark

There will be some days when the beauty of the Lord is evident all over you. On other days, you may feel like your heart is stuck in a wilderness. You may be pressed on every side and sense God calling you deeper. During these times, you are presented with an opportunity to receive His beauty. Your flesh may desperately desire to escape the uncomfortable feeling. However, your spirit longs for greater intimacy with God no matter what the cost.

If you decide to hear His voice and follow Him, you will be amazed at the growth produced within you. Spending time in His presence and transforming your beliefs produce His beauty, but nothing can compare to the beauty created from a heart completely set on Him. Sacrifice will always precede an increase of His presence. When you have more of His presence, you also have more of His beauty. Romans 12:1 states, "Therefore I urge you, brethren, by the mercies of God, to present your bodies a living and holy sacrifice, acceptable to God, which is your spiritual service of worship."

When you sacrifice your body, time, and plans to God He sees it as worship. Worship not only delights His heart, but it aligns your heart in a position to receive more of Him. In order for an act to be considered a sacrifice, it cannot be easy. Sacrifices will stretch you, develop your

faith, and cause you to lean on Him. If you allow sacrifice to mark your heart, you will also see the unfolding of His blessings in your life.

Abraham set the perfect example for a heart completely surrendered to God. After waiting many years for God to fulfill His promise of a son, Abraham and Sarah finally had Isaac. They loved to watch Isaac grow and were constantly in awe of God's faithfulness to His word. In his heart, Abraham knew God wanted to reveal more of Himself to him, but he wasn't sure how it would take place. But then the needed sacrifice became clear as God spoke to Abraham. Genesis 22: 1-3 tells the story that would forever alter Abraham and his descendants' lives. It says,

> Now it came about after these things, that God tested Abraham, and said to him, "Abraham!" And he said, "Here I am." He said, "Take now your son, your only son, whom you love, Isaac, and go to the land of Moriah, and offer him there as a burnt offering on one of the mountains of which I will tell you." So Abraham rose early in the morning and saddled his donkey, and took two of his young men with him and Isaac his son; and he split wood for the burnt offering, and arose and went to the place of which God had told him.

Instead of avoiding the sacrifice or offering something less valuable, Abraham simply obeyed. He knew what God was calling him to do and he did it. He never stopped to ask God a million questions or delay in his response. It clearly says, "So Abraham rose up early in the morning and saddled his donkey ..." He trusted God knew what He was doing. Abraham knew no matter what he laid down, God would never disappoint him. Since Abraham walked through years without a son, he learned to continue to hold on to God's promises. He was strengthened and learned of God's faithfulness during the process. Abraham was building a history with God as he waited for a son, which was needed at the sacrifice in Moriah. He didn't arrive at this level of faith overnight, but instead, it was a daily process of deciding to trust God no matter what his circumstances appeared to say.

When that day came for Abraham to decide to sacrifice the greatest joy in his life, he didn't doubt God. He was fully prepared to make the right decision. God had proven Himself trustworthy in the past, and Abraham knew He would do the same again. So, Abraham boldly and confidently prepared to sacrifice his prized possession all for the sake of honoring God. The Father saw his obedience as so beautiful that He not only saved Isaac, but He also offered a ram for the sacrifice instead. Abraham's faithfulness in the tough times brought him to the most

fulfilling season. God met every need of Abraham's heart by declaring this promise,

> By Myself I have sworn, declares the Lord, because you have done this thing and have not withheld you son, your only son, indeed I will greatly bless you, and I will greatly multiply your seed as the stars of the heavens and as the sand which is on the seashore; and your seed shall possess the gate of their enemies. In your seed all the nations of the earth shall be blessed, because you have obeyed My voice. (Genesis 22:16-18)

In the moment, Abraham could have easily backed away in order to preserve the life of his son. But he regarded God as most important and laid everything on the line. Since he was willing to be obedient in the challenging times, God granted him with the beauty of leaving an inheritance and impacting nations. Though you may not be asked to sacrifice your child, the Lord will ask you to lay down something. When He speaks that command to you, He is also offering something in return. He is not a stingy God who only desires to consume, but He delights in giving to you. Yes, He wants to give to you, even in times of testing. In Abraham's situation, he received the blessing of a lifetime, literally, in exchange for his commitment. If

Abraham tightly held on to his son and refused to offer him to God, he would have never left such a legacy as he did. God's beauty is not just found in spending time in His presence, but it is also produced from living a sacrificial life. A life marked by abandonment to the Father is a life that is guaranteed to carry His beauty.

If you are a single woman, or ever have been (which is all of us) you are familiar with the desire to meet a man and fall in love. I found myself in this season when it seemed like everyone else was engaged and getting married. If you would have asked me the hardest thing to surrender to God my answer would have been a relationship. Well, that is exactly what God asked me to do. I was placed in a situation when a man I was very interested in was pursuing me. As I started to fall for this man more and more, I heard God say the very thing I didn't want to hear. He spoke to my heart and said, "Sacrifice it." My mind immediately remembered the story of Abraham and I knew this was an opportunity to prove my faithfulness to God.

So, I decided to climb the mountain, bring my offerings, and burn the very thing I wanted the most. The sacrifice was not easy, but the relationship I surrendered was replaced with joy. This joy was produced from knowing that I passed the test and I showed myself trustworthy. After being obedient, I heard God again whisper to my heart. He said, "I am so proud of you. You have been faithful in all

things, and I will show you My faithfulness in return."
Since I was obedient in the sacrifice, the Lord brought me
to a new season marked by His blessings.

Just as God gave Isaac back to Abraham, the Lord
gave this man back to me. We were both obedient in laying
down the relationship and God honored that. He saw our
desires, knew our hearts, and brought the relationship back
into our lives in the most perfect timing. If I were
disobedient to God, my relationship would not be built on
the right foundations. Also, my priorities would not be in
godly order either. God provided a relationship blessed by
Him because I was willing to honor God above any earthly
man, no matter how handsome. The sacrifice I made was
uncomfortable and scary at times, but it allowed me to
experience the beauty of His trustworthy character like
never before. I felt so much peace as I knew He held my
future. I didn't need to worry or stress myself out about
meeting the right guy. I could confidently place my heart in
His hands, trusting that He would lead me in the right
direction. This opportunity connected me with a facet of His
beauty that I would have never experienced without it. If I
were not willing to make a sacrifice at my own Mount
Moriah, I would have missed out on experiencing a deeper
revelation of God. Since this moment required vulnerability
and humility, the Father saw that and perfectly illustrated

His beauty in that moment. My act of obedience left a beauty mark from the Father on my heart. This beauty mark is not embarrassing, but it radiates the love and faithfulness of heaven. Also, His mark of beauty on my heart pushes me forward as I rest at the banqueting table.

When you feel God pulling on the strings of your heart, listen to what He has to say. If you are obedient and pass the test, you could walk in His beauty like never before.

When I imagine a woman of beauty and royalty, I picture a sparkly gold crown on her head. In her crown, the sturdy gold holds rare gems and reveals its high worth. Her crown cannot be placed on anyone's head, but the wearer must prove to be a member of the royal family as well. Furthermore, they must share the name of the family and prove to be trustworthy in taking care of such a precious crown. A gold crown is not taken lightly because it is a beautiful metal only a few can obtain. Gold is important because it is pure, glimmers in the sunshine, and represents royalty. However, gold is not ready for display until it is purified in fire. Within heat, gold's impurities arise to the surface and they can easily be scraped off. Without a refining fire, the gold would never reach its fullest potential or experience what it was really created for. The fire makes it fit for its proper task as it eliminates impurities of all kinds. 1 Peter 1:7 (NLT) says,

These trials will show that your faith is genuine. It is being tested as fire tests and purifies gold—though your faith is far more precious than mere gold. So when your faith remains strong through many trials it will bring you much praise and glory and honor on the day when Jesus Christ is revealed to the whole world.

When you hear God say, "Sacrifice it," remember the refining process of gold. Yes, the fire will burn and you may feel all alone, but you will arise pure and shining with His beauty! Gold comes at a high price because it has endured the refining process. Just as gold is valuable, a genuine faith is precious in the eyes of the Lord. In your moment of testing, focus your mind on the purity of gold. Each test you pass makes your faith shine a little bit brighter and prepares you for the tests ahead.

To be gold in the kingdom, you must pursue a pure life. The key to living purely is by listening to the Holy Spirit. He will guide your decisions, actions, and words if you let Him. You will never have to compromise your identity or worth when you follow Him. He will constantly call your forward as you offer sacrifices to the King. I know it's not fun to talk about sacrifice, but it is crucial in the kingdom. Jesus set the ultimate example of sacrifice for us to walk in. If even Jesus couldn't ignore the importance of

denying the flesh, then it must be important for us too. A life of purity is on the pathway to His righteousness. It places you in the perfect position to receive His favor and blessings. 2 Timothy 2: 20-21 says,

> Now in a large house there are not only gold and silver vessels, but also vessels of wood and of earthenware, and some to honor and some to dishonor. Therefore, if anyone cleanses himself from these things, he will be a vessel for honor, sanctified, useful to the Master, prepared for every good work.

When God calls you to lay something down, see it as an opportunity to resemble gold. The longer you stay faithful in the fire, the more you will shine in the next season. Also, the more you are obedient during the refining, the more equipped you are for what God has called you to do. When you lay a desire down, it can be easy to assume you will never receive that desire back. However, many times when you sacrifice a dream, He will give it back to you. The dream He gives back will be more fulfilling than any dream you try to produce. Every moment the Lord calls you to trust Him, He is also offering to mark you with beauty. Daughter, do not overlook the small sacrifices made in secret, for the Father notices. The Lord has seen every

act of obedience and is faithful to fulfill His word to you. With each season, He is adding another mark of His beauty within you. At the end of your life, your heart will be so marked by Him that the only thing you have left to do is shine.

Instead of running from sacrifice, what if we ran to it? I know that sounds contrary to the desires of our flesh, but the more of God you crave is actually found in your sacrifice. The goal is not to amaze God with your sacrifices. Your real goal is to purify yourself as you continually decide to choose Him over and over. The King knows you better than any person on this earth and He is passionately pursuing every inch of your heart. For Him to fully capture you, you must let go of ungodly desires and align your heart with His. You are fully capable of becoming a woman of gold in the kingdom. If you are faithful in allowing the Holy Spirit to search your heart, receive the truth He offers, and transform how you treat others you are on the golden pathway of His heart.

Questions to Ponder:

1. Abraham and Sarah waited years for God to fulfill His promise of a son. What are some promises in your own life that you are still waiting to be fulfilled?

2. As you continue to wait and trust in God, how can you practice sacrifice in your life? Remember, everything

God leads you to sacrifice purifies your heart and prepares you for the blessing He wants to give you.

3. What are some areas in your life that need refining fire? Every dream and desire you place in the fire only comes out stronger and more prepared than before.

4. Ask God how you can be obedient in the small things and live a life marked by His blessings. Spend some time listening to what He says and write it down.

Chapter Eighteen: The Last Step

As I wrap up this book, I hope you have been encouraged and motivated as we have discovered the deep nature of God. God is not limited to your past experiences, but He is alive and eager to meet with you. The Father absolutely adores you as a daughter. The Son embraces you as a friend. The Holy Spirit desires to counsel and direct your life. When you feel overcome by confusion or weariness, the living water of the Word is awaiting to refresh you. You are not alone in your journey of life, but the three greatest friends in this world have already gone before you.

My heart is for you to connect with each Person of the Trinity in a meaningful way and allow His beauty to fill your life. His beauty may take the form of grace, forgiveness, or healing. Whichever way His beauty meets you, I desire for you to embrace it and let it direct how you live. As a woman, there is no need for you to settle for merely earthly beauty. You don't need to settle because a rich, never-ending divine beauty is awaiting you and reserved with your name on it. God wants to fill you with His character as you come to know Him better. Beauty of this world will always chase after the newest fad, but His beauty will never go out of style. His gracious words, hopeful eyes, and pure heart will transform your mind

along with your attitude. The longer you taste and see who He really is, the more you will start to smell and look like Him—and that, my friend, is real beauty. The beauty He fills you with never struggles with comparison or strives to reach first place. His beauty is true satisfaction as it leads you to accept your God-given identity and walk in your purpose.

No matter what others have said, you are not merely a number. You are not another face in the crowd. Most importantly, your life is not meaningless. You have been designed by the Creator Himself for an intimate relationship with heaven. He created your desire to feel beautiful and He plans on fulfilling that need with Himself. Every dream in your heart can find fulfillment in the hands of the King. When you partner with Him, He reveals your worth and empowers you to live a beautiful life.

Your journey in discovering His divine beauty has only begun. Moving past this book, you will meet hills, valleys, stormy weather, and glorious sunny days. Whatever season you find yourself in, rest assured that He is with you for the long run. Even when you feel overcome by the demands of life, He is still extending His beauty to you on a gold platter. God is committed to you and He hungers for your faithfulness in return. He longs to walk with you as you understand His extravagant plans for each day. Not

only does He want you to know His beauty, but He wants to strengthen you too, so you can live it out yourself.

I pray that your heart to connect with a father has found rest in the Father. I hope your desire for a close friend and supporter has discovered fulfillment in Jesus. I hope your need to find direction, power, and counsel has found answers in the reliability of the Holy Spirit. If you let Him fill your every need, you will find solutions while also finding the One your soul longs for. Daughter, no matter how far you have run, He is standing before you and offering an invitation. I dare you to reach forward and follow Him as He takes you on the sweetest pathway life has to offer. He is a beautiful God who constantly has more to reveal.

Imagine a life marked by continual revelation of the beauty of the Lord—you don't even have to imagine it, because it can be yours. You can experience every truth I have presented to you! The simple fact that you are a royal daughter guarantees that He wants to meet with you. Divine beauty is not only reserved for heaven, but it is a name He wants to call you—A Daughter who truly is Divinely Beautiful.

Bibliography

Chapter 1: Beauty - Redefined
1. "Dove research: The Real Truth about Beauty: Revisited," http://www.dove.com/us/en/stories/about-dove/our-research.html. Accessed August 17, 2016.

Chapter 2: Alive Perfume
1. Easley, Kendell H. "2 Corinthians." 2010, p. 1993. *HCSB Study Bible: Holman Christian Standard Bible*, general editors, Edwin A. Blum and Jeremy Royal Howard, Nashville, TN: Holman Bible Publishers. Print.

Chapter 4: The Father's Heart Exposed
1. Manwaring, Paul. "Releasing Fathers: Revealing the Father," (sermon) Bethel Church. (direct quote)

Chapter 6: Crowned from Him
1. Massa, Mike. Direct quote. Christ for the Nations Institute.

2. Duguid, Iain M. "Ruth." 2010, pp. 433-438. *HCSB Study Bible: Holman Christian Standard Bible*, general editors, Edwin A. Blum and Jeremy Royal Howard, Nashville, TN: Holman Bible Publishers. Print.

Chapter 8: Past the Crowd

1. Luter, A. Boyd. "Luke," 2010, pp. 1752-1753. *HCSB Study Bible: Holman Christian Standard Bible*, general editors, Edwin A. Blum and Jeremy Royal Howard, Nashville, TN: Holman Bible Publishers. Print.

2. Farrell, Heather. "Woman with an Issue of Blood," April 16, 2012. http://www.womeninthescriptures.com/2012/04/woman-with-issue-of-blood.html. Accessed August 17, 2016.

Chapter 9: Found in the Vine

1. NAS Exhaustive Concordance of the Bible with Hebrew-Aramaic and Greek Dictionaries Copyright © 1981, 1998 by The Lockman Foundation (John 15, "*meno*")

Chapter 10: The Person of the Holy Spirit

1. Bevere, John. Paraphrase. Christ for the Nations Institute. (His ministry is Messenger International and his book, *The Holy Spirit: An Introduction*, is a great read.)